CW00951461

SECRET
STOCKPORT

Ian Littlechilds & Phil Page

AMBERLEY

About the Authors

Ian Littlechilds and Phil Page are professional photographers and writers who have been working together on a number of photographic projects since 2005. After running a wedding photography business for over five years, they embarked on book projects to further improve their photographic, writing and research skills. Both have lived and worked in Greater Manchester for over thirty years. This is their sixth publication for Amberley, their previous five being: *The Four Heatons Through Time* (2013), *River Mersey from Source to Sea* (2014), *Secret Manchester* (2014), *From Bugsworth to Manchester, History of the Limestone Trail* (2015) and *The Four Heatons: The Postcard Collection* (2015). In addition to writing, they deliver talks on local history to community groups in Greater Manchester, regularly contribute articles to local publications, and run workshops on the development of photography skills to both adults and children.

First published 2017

Amberley Publishing
The Hill, Stroud, Gloucestershire, GL5 4EP
www.amberley-books.com

Copyright © Ian Littlechilds & Phil Page, 2017

The right of Ian Littlechilds & Phil Page to be identified as the Authors of this work has been asserted in accordance with the Copyrights, Designs and Patents Act 1988.

ISBN 978 1 4456 5136 1 (print)
ISBN 978 1 4456 5137 8 (ebook)

All rights reserved. No part of this book may be reprinted or reproduced or utilised in any form or by any electronic, mechanical or other means, now known or hereafter invented, including photocopying and recording, or in any information storage or retrieval system, without the permission in writing from the Publishers.

British Library Cataloguing in Publication Data.
A catalogue record for this book is available from the British Library.

Typesetting by Amberley Publishing.
Printed in Great Britain.

Introduction

The purpose of this book is not to write a comprehensive study of the obscure and hidden secrets of Stockport. What we have tried to do is to explore some of the well-known places in the borough, along with others of which even established residents may be unaware. We hope that by reading our book you may be inspired to visit these places, view them through new eyes, and develop a thirst to discover even more knowledge about Stockport's fascinating past and present.

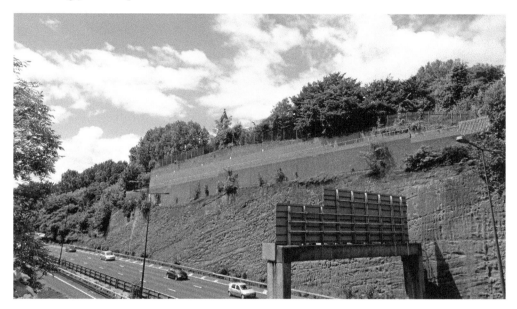

Above: The town of Stockport stands on a bed of Permian and Red Triassic sandstone laid down over 240 million years ago.

Right: Merseyway prior to the demolition of the Victorian fire station and the construction of the new precinct.

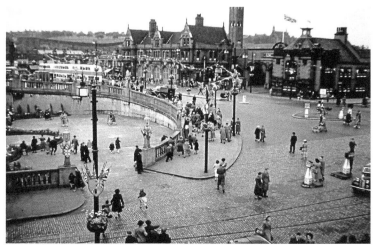

Some Important Dates In Stockport's Development

AD 393	Date of a Roman Coin found in the eighteenth century during levelling of the castle.
1220	Stockport is made a free borough.
1260	Prince Edward grants Stockport a weekly market and annual fair.
1487	Stockport Grammar School is founded.
1665	Deaths from the Great Plague reach 168.
1775	Stockport Castle is demolished.
1797	'Troglodytes' reported living in the sandstone caves.
1822	*Stockport Advertiser* is first published, priced 7d.
1826	Wellington Road opens.
1833	Stockport Infirmary opens.
1840	Manchester to Heaton Norris railway opens.
1842	The railway is extended across the new viaduct.
1843	Edgeley Station opens.
1852	Anti-Irish riots.
1858	Vernon Park opens.
1862	The covered market opens.
1865	Tiviot Dale Station opens.
1868	St Petersgate Bridge is completed.
1875	The public library opens over Market Hall.
1890	Heaton Norris Rovers become Stockport County.
1908	Town Hall is opened by the Prince of Wales.
1913	New Central Library founded.
1932	Plaza Cinema opens
1938	Air-raid shelters constructed on Chestergate.
1967	Stockport Air Disaster.
1968	Merseyway construction begins.
1972	Stockport twinned with Beziers
1982	M63 motorway arrives in the town centre.
1982	Stockport is twinned with Heilbronn.
1998	Stockport County's highest league place 8th in Division 1 (Championship).
1999	M63 becomes the M60.

Stockport Town Centre

Key to Locations

1 Underbank Hall
2 Air Raid Shelters
3 St Peter's Church
4 Plaza Cinema
5 Hat Museum
6 Stockport Viaduct
7 Turner's Vaults
8 Mealhouse Brow
9 Rostron Brow

10 St Mary's Church
11 Market Place
12 Arden Arms
13 Lavenders Brow
14 The Tin Brook
15 Air Crash Memorials
16 War Memorial Art Gallery
17 Strawberry Studios
18 Town Hall

19 Central Library
20 Cobden's Statue
21 Millennium House
 (Old Infirmary)
22 Start of River Mersey
23 Staircase House
24 Robinsons Brewery
25 The Armoury
26 Coopers Brow

Around Stockport

Stockport developed as a town because of its location at an important ford over the River Mersey. It was the meeting point for several Roman roads and presented itself as a natural defensive position. After the Romans left, the Saxons constructed a village on the site and named it Stockport, meaning 'the marketplace at the hamlet'.

Take a walk into the town centre and you'll see that many of the old trade routes are still present. To the north of the town, Dodge Hill rises steeply from the bottom of Lancashire Hill and its old houses and cobbled street retain much of its historic charm. Like much of the town centre, it is carved out of the familiar red sandstone, sitting behind the massive red cliff face, which fronts onto the M60 and holds aloft St Mary's Roman Catholic Church and was home to one of Stockport's air-raid shelters during the Second World War. The main set of shelters sit on the south side of the town just off Chestergate and can be visited by doing the official Stockport Air-Raid Shelter Tour.

These shelters back onto another significant outcrop of sandstone called Pickford's Brow which rises steeply from the street to the higher level route of Petersgate. The natural rock upon which most of the town is built was tunnelled into to form the nearby air-raid shelters.

After you have crossed the river into the southern part of the town, you will enter the area around Stockport Market and Great Underbank. This is the town's historic core. The close-knit construction of the buildings and the pattern and development of the streets has altered little over a period of 300 years.

There are a number of these old, narrow routes on the southern side of the town which, in their day, were busy thoroughfares. Bridge Street Brow is a familiar steep climb, which rises up from the river to the marketplace. It has also been known as Kelso Bank and Brierley Brow and before the construction of St Petersgate Bridge was part of the favoured north–south route, which ran down Dodge Hill, across Lancashire Bridge and up through the market.

Cooper's Brow, on Lower Hillgate, is named after George Cooper, the town crier in 1835. It is another street and was an original part of an ancient road leading to 'Top O' the Hill' (now the High Street), onto Bear Hole and then to Chestergate.

Also on Lower Hillgate are two steep climbs leading up to the Market Place. Rostron Brow (originally Rosen Brow) was named after a local farmer called Ralph Rosen. It was one of the old routes linking Lower Hillgate to the market square. The slope of the brow was reduced in the late seventeenth century when the Tin Brook, which runs from Hopes Carr, was culverted below the town centre. At one time timber-framed buildings lined each side of the Brow and it was infamous for its alehouses, which were generally of ill-repute. The most famous of these was the Dust Hole, which closed in 1896.

Mealhouse Brow, previously known as Wynn Hill, was one of the main access roads linking Lower Hillgate with the market and castle before the building of St Petersgate Bridge. The old town wall passed across the Brow, which at the time would have meant negotiating a small entrance through the wall in the climb up to the marketplace. A local farmer named Jonathan Thatcher from Offerton became famous nationwide in 1784 when he rode a saddled cow

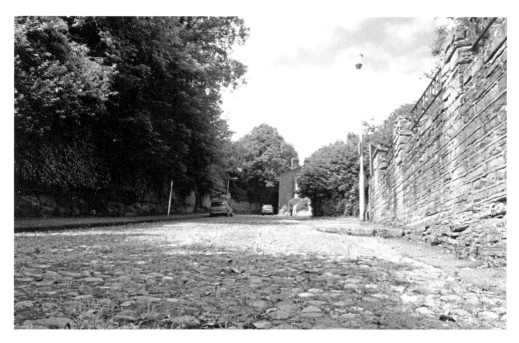

The route up Dodge Hill from the town centre was a steep climb for travellers and commercial traffic.

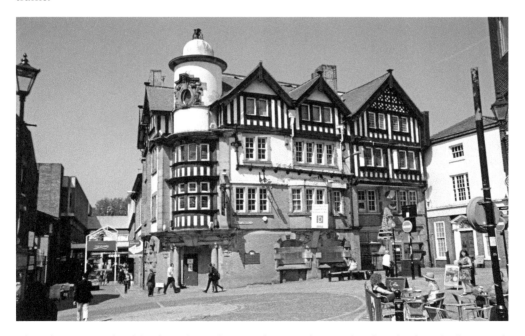

The White Lion is the oldest hostelry in the town, having a licence that dates back to the fourteenth century. In 1814, during the battle of Waterloo, the landlord fired a canon to inform the locals of Nelson's victory. A 'Wife Sale' also took place here in 1831 when William Clayton accepted a payment of 5s and handed her over with a halter around her neck to the purchaser, J. Booth.

up the Brow in protest against a tax on saddling horses. At the top of the Brow is Stockport Dungeon. It had been used as the town lock-up and, in 1790, took on the role of Stockport's meal-house since the old premises for storing meat and cheese, the court leet, had become unsuitable for storing foodstuffs. Prior to 1824, the town's justice was administered from the building and prisoners were held in the small, dark cells beneath the ground, accessed through the main door or from the wooden entrance on the side of the Brow.

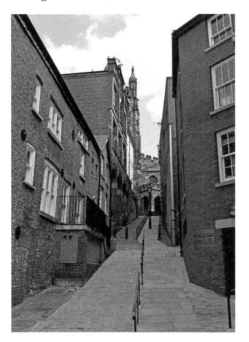 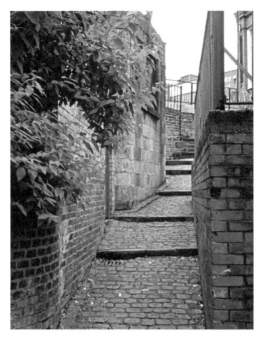

Above left: Rostron Brow. *Above right*: Cooper's Brow.

Below: Stockport dungeon provides some macabre suprises for visitors.

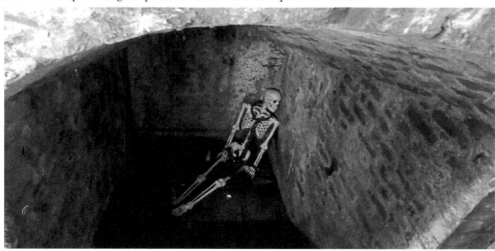

The small wooden opening in the lower right of the dungeon wall allowed food to be passed to prisoners by friends and relatives.

The steps leading up from Underbank to St Petersgate and Stockport Market are a feature of the area.

Robinsons Brewery

Based in the heart of Stockport for almost two centuries, and owning 280 pubs, inns and hotels across the North West, Robinsons is one of the oldest and most respected names in British brewing history and somewhat of a Stockport institution.

The brewery has been owned and run by the Robinson family all that time – one of the many reasons Robinsons are a bit different from many brewers. The family still runs the business on a day-to-day basis, with eleven family members fully involved at this time. The longest-serving member of the family has worked at the brewery since 1953; the three senior members of the family have over 150 years of experience between them. The current joint managing directors – Oliver and William Robinson – are the sixth generation descendants of Frederic Robinson, who took over the Unicorn Inn in 1838 – the original pub from which the brewery now stands and derives its name.

A proud family of independent brewers, Robinsons now owns one of the most advanced and sophisticated breweries in the UK, with a worldwide reputation for real ale. It's also home to the largest hopnik in the world (which strains hops to maximise aroma and flavour). From here, decades of experience is applied to create exciting new varieties and choices of flavour that will lead the family brewers towards their next award-winning beer.

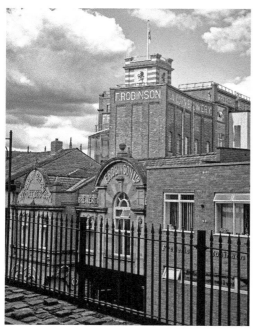 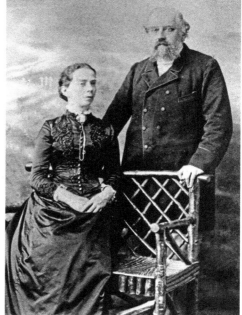

Above left: Robinsons Brewery is situated in the heart of Stockport.

Above right: Frederic 1836–90 and Emma 1839–1921.

Robinsons Heritage

Unicorn Brewery rests over the foundations of the Unicorn public house, marking the beginning of a family business. After twelve successful years as the landlord of the Unicorn, Lower Hillgate, Stockport, William Robinson (a cotton-overlooker from Bollington) purchased the inn from Samuel Hole on 29 September 1838. By 1847 William had remarried after the early death of his wife Juliet and moved to Heaton Norris, leaving George, his oldest son, to run the inn with his wife and sister-in-law. George started to brew the first Robinsons ale at this time

William's younger son Frederic took the helm from George in 1859 and he bought a warehouse to the rear of the Unicorn Inn so that brewing capacity could be expanded. As a result, during the 1860s Robinsons ale was available at a number pubs in and around Stockport. Frederic decided to buy a number of public houses in order to control the quality of conditions in which the ales were sold by independent publicans; between 1878 and his death in 1890 he established twelve exclusive outlets for Robinsons ale, beginning what was to eventually become an estate of more than 280 pubs across the North West and Wales.

Fast forward to the early twentieth century and Frederic's grandchildren, sons of William, joined the family business. After Frederic's passing, his widow Emma owned the business and it was shortly before her death that she instigated the formation of Frederic Robinson Limited. Fourth generation Robinsons – Frederic, John, and Cecil – joined the board and continued to build the company alongside their father William.

Bottling commenced from a new building in 1908, there were new offices in 1913 and there was a new brewhouse in 1929. As such, despite the country's difficult economic climate, by the time of William's death in 1933 Robinsons was strongly positioned for further growth. Over the following years, the estate grew: new buildings were purchased and the geographical area was extended. The first Welsh house – The Black Lion in Llanfairtalhaiarn was bought in 1943. William Robinson would have been proud to hear that his great-grandchild John was honoured with a knighthood in 1958 for political and public services in Cheshire – 120 years after William purchased the Unicorn Inn. The early 1950s saw Peter, Dennis, and David (fifth generation Robinsons) join the business.

Over the past forty years Robinsons bottled ales became distributed worldwide and the sixth generation members of the family also joined the company. There has been a £5-million investment in a new brewhouse, and the Training Centre of Excellence and Visitor Centre opened. Robinsons also collaborate with the heavy metal rock legends Iron Maiden to launch the Trooper ale.

If you are interested in learning more about the Robinsons story, their Visit England accredited visitors centre reveals many secrets behind the brewing process. You'll also get the opportunity to meet two of the few remaining 'working' shire horses in the British brewing industry – Hopnik and Wizard.

The Robinsons Story

The story of Robinsons is one that stretches back over 178 years; from humble beginnings to becoming one of the UK's largest independent family brewers, with 280 pubs across the North West and Wales. The date 29 September 1838 is a landmark date in the history of Robinsons Brewery.

1838 William Robinson purchases The Unicorn Inn, Lower Hillgate, Stockport, from Samuel Hole.

1847 William remarries, moves to Heaton Norris, leaving George, his eldest son, to run the inn. George starts to brew ale.

1859 William's younger son Frederic takes over the pub and buys a warehouse behind it, so brewing capacity can be expanded. Robinsons' ale is now available to a number of pubs in and around Stockport.

1875 Founder William Robinson dies Sunday 15 August.

1878 In order to build up a secure market for his ales, Frederic buys twelve public houses exclusively for Robinsons' ales between now and his death.

1890 Frederick dies on 6 February and the Unicorn Brewery passes to his widow Emma and their sons William and Herbert (William took the lead role in business matters).

The Family Heritage

1893 Emma, William's eldest sister, marries Robinsons Head Brewer Alfred Munton, who joined the firm following the 1890 brewery enlargement.

1899 Frederic and Emma Robinson's son, William, marries Priscilla Needham on 2 October and Robinsons began brewing Old Tom; dubbed 'the original craft beer', Old Tom has since won the prestigious title of World's Best Beer multiple times.

The Early Twentieth Century

1901 Frederic's widow Emma owns the business.

1908–10 William continues the expansion of the Unicorn Brewery. Bottling commences in a new building and Robinsons own thirty public houses by 1910.

1911 William's eldest son, Frederic, was one of the first brewers in Britain to gain a science degree (a BSc with honours in Chemistry from the Manchester Municipal School of Technology, now the University of Manchester Institute of Science and Technology). He went on to obtain a master's degree with 'yeast' as the subject of his thesis. He was later responsible for the company's first laboratory, a new brewhouse and the introduction of production control.

1913 New offices and a new brewhouse are built. The original archway still exists today.

1914–18 Female workers are employed to keep the beer flowing during the war years. Robinsons acquire John Heginbotham Ltd of the Borough Brewery in 1915 and, sadly, Robinsons Head Brewer Alfred Munton dies in 1918 (after twenty-eight years of serving the company). By 1918, all three of the fourth generation Robinsons' sons (Frederic, John, and Cecil) had joined the family business.

1920–21	Frederic Robinson 'Limited' is formed. On 7 October 1920 it was decided that the business should become a private limited company, which it has remained to this day. Emma appoints her son William as Chairman of the company in 1920 (until 1933). Emma dies on 18 April 1921.
1925–33	The empire continues to grow and the fourth generation Robinsons join the board in 1926. Robinsons acquire Schofield's Portland Street Brewery (Ashton-Under-Lyne) in the same year and Kay's Atlas Brewery Ltd (Manchester) in 1929. In 1925–29 a new brewhouse was built under the supervision of William's eldest son Frederic. An intensive refurbishment programme was carried out for Robinsons' pubs under the direction of John, and Cecil broadens the range of drinks available to Robinsons' customers. John marries Gwendolen Evans in 1926, who gives birth to the fifth generation of Robinsons sons: Peter (1931), Dennis (1933) and David (1937). Their grandfather, William (still Chairman of the company) dies on 25 January 1933 after serving the family business for fifty-five years. William was succeeded as Chairman by his son John.
1943	Despite the Second World War, Robinsons pressed ahead with their plans for pub acquisitions and in May 1943 purchased The Black Lion in Llanfairtalhaiarn – the first Welsh public house to be bought.
1949	The Robinsons estate continues to grow and Robinsons acquire Bell & Co. Ltd (Stockport).
1958	William's great-grandson and company chairman, John, is honoured with a Knighthood for political and public services. Between 1953 and 1962, all of Sir John's sons had joined the family business.
1975	A new-build packaging centre opens in Bredbury, and 15 October 1975 marks the first day of bottling of Robinsons 'Light Ale'.
1978–82	On 21 February 1978, Sir John – who had done so much to ensure the health and expansion of the company – suddenly dies at his desk at the brewery after being Chairman for forty-five years. His eldest son, Peter, took over as Chairman and so started the era of the fifth generation. The acquisition of Hartley's Brewery (Ulverston) and Robinsons' expansion into the Lake District then followed.

Robinsons bottled ales are now distributed worldwide and the sixth generation members of the family have joined the company. There has been a £5-million investment in a new brewhouse, a Training Centre of Excellence and Visitor Centre. Robinsons also collaborated with the heavy metal rock legends Iron Maiden to launch the Trooper ale.

The Robinsons story continues on page 35.

The Gates of Stockport

The Roman road from Manchester to Buxton crossed the Mersey at Stockport. Originally, this would only have been a ford but by medieval times it had been replaced with a bridge; the routes in and out of the town were becoming defined. The western entrances to the town were defined by Chestergate, which connected Stockport to its county town, and St Petersgate, which directed travellers across the town on an elevated route towards St Mary's Church and the market place.

Millgate (originally called 'Milne gate') is one of the oldest roads in Stockport, with its origins going back to the earliest days of the town's development. Millgate took its name from the corn mills that were situated at its lower end. The lord of the manor was the owner of two mills that supplied much of the corn for the town. They were both water powered and positioned at bends in the River Goyt: one on the site now occupied by Newbridge Lane car park and the other on the site of Sainsbury's.

The longest linear route into the town, however, is characterised by the Three Hillgates (Upper, Middle and Lower), which creates a strong sense of arrival for travellers entering

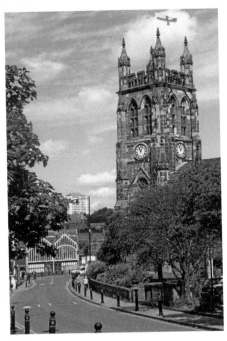
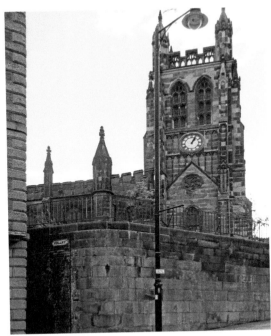

Above left: The sweep of Churchgate into the top end of Millgate is one of the most picturesque parts of the town.

Above right: A 'Folley' is the old name for a walled boundary of a churchyard, and this fine example on Millgate was originally the entrance to the almshouses of St Mary's Church.

the town from the south. The route still contains a multitude of buildings surviving from the Georgian, Victorian and Edwardian periods. However, the development of the 'Gates' dates back to much earlier times; their creation did much to expand the development of residential areas, businesses and industry during the seventeenth century. Toll Bar Street, opposite the Salvation Army Citadel on Middle Hillgate, is a reminder of the time when the Hillgates were the main route on the journey from Manchester to London. In the early eighteenth century, the condition of the roads was so bad that they were 'turnpiked' in order to raise tolls. The tollgate was positioned where the Salvation Army Hostel now stands.

The earliest known map of Stockport was produced around 1680 but documents refer to the establishment of Churchgate from as early as 1541. The road was the property of the parish church and once contained a continuous row of dwellings rising from the town. The Thatched House pub (now unoccupied) took its name from the row of buildings that were thatched and roofed up until the late nineteenth century. In the original building, James Briscall established Stockport's first dispensary in the 1770s. This timber-framed structure was replaced in 1899 by the present building with mock-Tudor woodwork on it upper floors. In the church grounds is St Mary's Gate, a short path between the church and the 'secret graveyard' leading to St Mary's steps. It is unusual in that it is the only one of Stockport's 'Gates' that has the word 'Gate' as a separate word in the name.

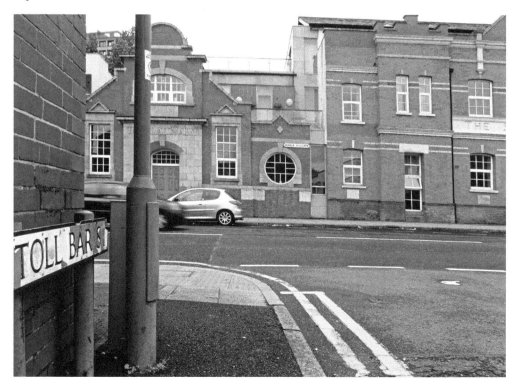

The Salvation Army Citadel on Middle Hillgate sits on the former site of the old tollgate.

Crowther Street was painted by L. S. Lowry in 1930. The original painting was purchased by Stockport Art Gallery in 1935 for 35 guineas and is now kept by Stockport Museum at Staircase House. The street's slang name was 'Bombers Brow' meaning the Brow of the Bailiffs. The housing around the area was notorious for moonlight flits.

By the eighteenth century, Stockport was a thriving market town, specialising in spinning, weaving and leather work. The Hillgates formed an important coaching route and contained a variety of inns, houses, shops and industrial premises. A network of streets branched out from the main road, which contained houses and factories, with Crowther Street (painted by L. S. Lowry) giving a good example of how steeply-sloping, stepped streets were set into the adjoining hillside.

Lower Hillgate retains many of the characteristics of its medieval development. The tightly enclosed streets and height of the adjoining buildings give a sense of the enclosure, which must have been felt when they were packed with shoppers and traders.

Middle Hillgate retains a number of original building frontages and, at Covent Garden, the road widens to reveal good examples of the original street surfaces. Most of the original buildings in Higher Hillgate have disappeared, with the exception of St Thomas's Church, which is the single most important building in the area.

One of the most interesting features on Middle Hillgate is the Enterprise Mural on the gable wall of No. 89. It was painted by artist Ken Ormondroyd in 1983 and offers a pictorial reflection of Stockport's industrial history. The first Society of Friends (Quakers) Meeting House was built on this site in 1705 but was subsequently demolished; the present building dates from 1910.

St Thomas's Church was opened in 1825 and built to front onto Higher Hillgate. Its grand portico at the east end of the church would have been an impressive sight for travellers entering the town, and the tower, cupola and clock face would have added to the their sense of wonder. The church was constructed using funded grants from the government as a thanksgiving for Napolean's defeat and is one of 100 places of worship known as the 'Waterloo churches'. It has undergone a period of restoration in recent years and is

now used as a venue for concerts and recitals. It is recognised as a building of national importance and is Grade I listed.

The church is one of six listed local buildings that have been designated as having special architectural or historic interest, the others being: Rayner House, No. 23 Higher Hillgate (Grade II); Samuel Oldknow's House, No. 27 Higher Hillgate (Grade II); the Star & Garter public house, No. 61 Higher Hillgate (Grade II); No. 16 Middle Hillgate; and Lion House, No. 16a/18 Middle Hillgate (Grade II).

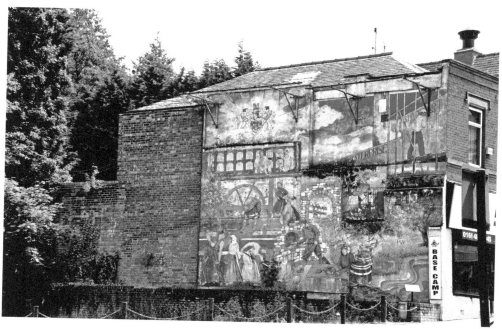

The Enterprise Mural of No. 89.

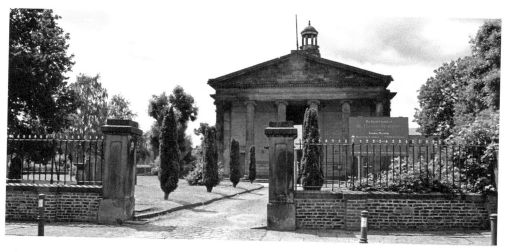

The Parish Church of St Thomas.

St Mary's Church and Graveyard

St Mary's Church is the oldest parish church in Stockport and stands on Churchgate overlooking the market. It is a Grade l-listed building. The gateway to the church, which was designed by Lewis Watt, is Grade II listed, as is the drinking fountain that stands nearby.

There has been a place of worship on this site since before the Norman period. The first official record of a church on this site dates from around 1190, but only the original oratory remains of this original structure. Around 1310, records of a new church appear with the chancel remaining from the earlier building. The present church was constructed between 1813 and 1817, with a further restoration taking place in 1848. The church tower, which dates from the fourteenth century, has been rebuilt twice: in 1616 and then in 1810, some five years after a partial collapse that was blamed on a marathon bell-ringing ceremony to celebrate Nelson's victory at Trafalgar.

The graves that surround the church give a fascinating record of some of the people who are important to the history of the town. A comprehensive study of the graves was completed by Jill Tumble in 2009 when all the gravestones were transcribed by hand and details checked against existing parish records. The graveyard was landscaped between 1968 and 1971 and the gravestones, now visible, are those that were selected to remain. Some of the more famous graves were relocated to make them more accessible to the public and can now easily be found by visitors to the churchyard.

Constable William Birch

On 23 July 1819, Constable Birch was shot in the chest by Jacob McGhinness at Loyalty Place, just north of the church, at around 10 a.m. He had been approached by three men enquiring about Revd Harrison, who had been arrested for sedition for his part in a radical uprising in London and was being questioned at Constable Birch's home. Before Constable Birch had time to open a discussion with the men, McGhinness produced a pistol and fired. Although seriously injured, the constable managed to crawl into a nearby garden where his calls for help were heard. He was taken to his father's house in Little Underbank where he was treated by a local surgeon but no trace of a bullet could be found.

It transpired that the bullet had lodged in his breastbone but, despite his injuries, he survived for a further fifteen years, continuing to work for the police force and reaching the position of High Constable and Inspector of Stamps, Weights, and Measures. He was awarded a sum of £120 a year for life as compensation for his injuries. After his death, the post-mortem revealed that his left lung was diseased possibly as a result of the shooting. His breastbone is on display in the Stockport Story Museum in the marketplace. Jacob McGhinnness was tried at Chester assizes and sentenced to death for the shooting.

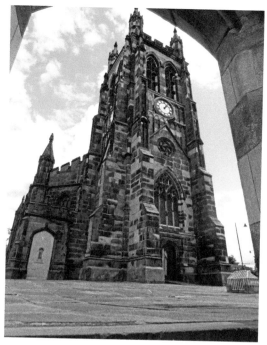 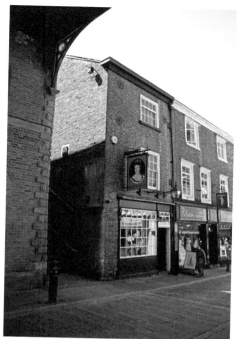

Above left: St Mary's Church.

Above right: The Queen's Head on Underbank is known as Turner's Vaults.

James Thorneley

James Thorneley was a local Freemason and his resting place is known as the 'Moon Grave'. His wife Susan is buried with him and their ages are recorded in moons instead of years: 1,045 in the case of James and 737 for Susan. These equate to actual ages of eighty-eight and sixty-one years and were probably calculated using the Lunar Calendar of Freemasonry rather than the existing Gregorian one.

William Turner

William Turner was a wine merchant who took over the running of the Queens Head on Underbank in 1809, where he presided until his death in 1841. William's name lives on, of course, as the pub is also known locally as 'Turner's Vaults'. Despite the restrictions of its size, it manages to house a three-room layout within its confined space and alcoves and a wood-burning stove around the narrow bar. It even has a quiet room located to the rear of the premises and is famous for having the smallest gentlemen's toilet in the country.

Almshouses

Almshouses are one of England's oldest charitable traditions. They were usually provided by the lord of the manor to house poor and needy people within his estate. Although they are no longer there, the almshouses built behind St Mary's Church are commemorated on a plaque at the top of the steps from New Bridge Lane. They were bequeathed to the church by Edward Warren in 1683 but were demolished at the same time as his townhouse, Millgate Hall, in 1927.

Other almshouses were dotted around the borough and include those at Long Lane in Cheadle, the Bridge Almshouses for Marple widows, and a cluster of six houses near Reddish South Station for the old and infirm of Reddish, Denton, and Bredbury.

James Ainsworth of Heaton Norris left provision in his will for twelve semi-detached cottages, with gardens and a stone entrance archway, to be built on Green Lane in 1907. The Grade II-listed buildings were built by Pierce & Son in 1907, and the red and grey brick design, with red-terracotta dressings, is very distinctive. There are twelve properties, with both end houses having corner turrets with lead domes. Today, the almshouses are let by the Arcon Housing Association to the over-sixties residents of Heaton Norris.

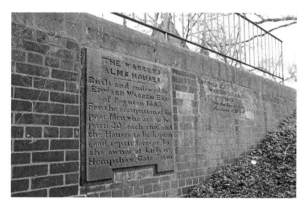

The plaque commemorating St Mary's almshouses can be seen on the southern wall of the church, above New Bridge Lane.

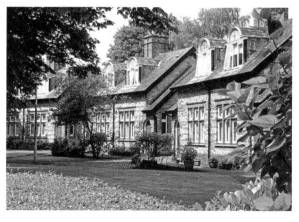

The almshouses sit at the end of Green Lane in the local conservation area.

The Market Place and Surrounding Area

The historical centre of Stockport is the Market Place, which is situated on a 240-million-year-old red sandstone cliff overlooking the River Mersey. A weekly market has been held since around 1260, when Stockport was granted a market charter by Prince Edward, Earl of Chester. The glass-covered Market Hall, which originally had open sides, was built in 1861 and opened for trading in 1862. Emphraim Marks, whose brother Michael became one-half of Marks & Spencer, was the stallholder on No. 1 stall during the late 1800s. The Market Place is now an undercover market that houses many independent traders. It is one of the last remaining traditional street markets in the North West and was given Heritage Lottery Funding in 2009 to redevelop the historic, covered Market Hall building. There is much to see, learn and do in and around the Market Place, namely taking in the 750-year history, the Victorian cobbled streets and architecture, and, of course, the shopping experience.

Stockport Castle

Stockport Castle once stood in an area around the Market Place now called Castle Yard. The castle was mentioned in 1173 when Geoffrey de Costentyn occupied it. It fell into decline during the fourteenth century and was finally demolished in 1775. The medieval castle was an urban structure, built above the confluence of the rivers Goyt and Tame where they become the River Mersey. A castle with two towers appears on the official blazon of Stockport.

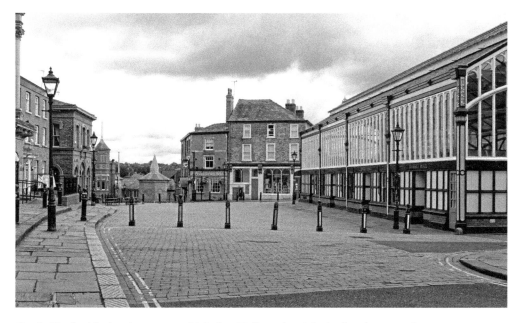

Castle Yard with the glass-covered Market Hall on the right in the photograph.

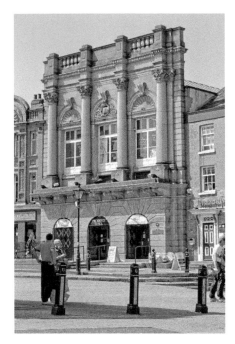

The Farm Produce Hall
The Farm Produce Hall, or Cheese Hall, was built in 1852 and was originally a single-story building; the upper storey was added in 1875 to house a library. The upper storey has attached Corinthian columns, marking the bays of three windows. The building is Grade II listed and the architects were J. Stevens and G. B. Park.

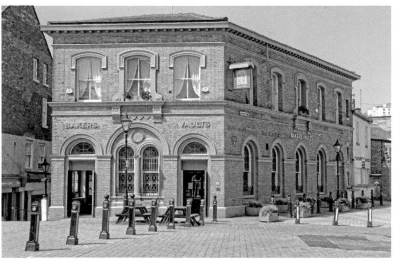

Baker's Vaults.

Baker's Vaults

Baker's Vaults is a two-storey brick building and was built during the mid-1770s. The ground floor front has two round-headed doorways and in the centre is a two-light round-headed window. The upper floor has three windows with segmental arches and stucco-shaped heads. The building housed a hostelry called the George & Dragon from 1824. It was renamed Baker's Vaults in 1861, in honour of Mayor Charles Baker, after it was rebuilt to make room for the Market Hall. A vault was a cellar for wine storage during the eighteenth century. It is now a Grade II-listed building.

Stockport Story Museum

The numerous galleries in the museum offer a unique glimpse into the life of medieval and Renaissance Stockport. It takes visitors of all ages on a 10,000-year Stockport journey, where they can experience life in Stockport during the Iron Age, medieval times, the Victorian era and the First World War.

Staircase House

Staircase House is Stockport's oldest house and now showcases how our ancestors lived from the fifteenth to the twentieth centuries. The beautifully restored townhouse has one of only three surviving Jacobean cage-newel staircases in the country and includes the unusual feature of the carving covering much of the woodwork. It is a Grade II*-listed medieval building, dating from around 1460. The house and staircase have been totally restored using traditional materials, tools and techniques following a fire in 1995, which was the second fire in what was a semi-derelict building at the time. The visitor is offered an audio guide that recounts the full history and stories of the house. Staircase House is furnished in different period styles, from the 1600s to 1940, to show that the house was continuously occupied for over 500 years.

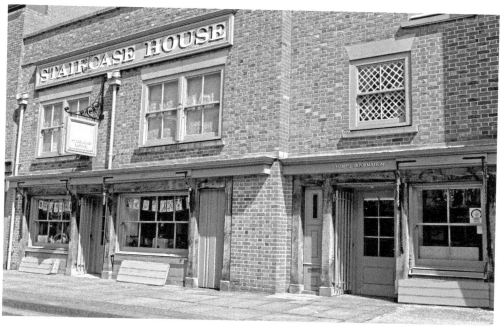

Staircase House.

Around the Town

Stockport Town Hall

The Town Hall was designed by Sir Alfred Brumwell Thomas and was opened by the Prince and Princess of Wales in July 1908. The white limestone façade and tiered clock tower, which rises 130 feet above the pavement and is nicknamed 'the wedding cake', is a Renaissance-style building and was listed Grade II* in September 2007. The magnificent interior includes stained glass, a marble staircase and wood carvings inspired by Grinling Gibbons. One of the chambers has elaborate plasterwork, decorative carvings on oak benches and brass chandeliers; in the corridor outside the chamber is the civic silver collection, some of which dates back to the fifteenth century. The Great Hall, an Edwardian ballroom, houses a Wurlitzer organ. The Wurlitzer (Opus 2120), a Publix 1 (four manuals, twenty ranks), is one of only sixteen of its kind in the world and is the only such model to leave the United States. It was designed by American theatre organist Jesse Crawford and was originally purchased for the Paramount/Odeon cinema in Manchester 1930. It is now owned by the Lancastrian Theatre Organ Trust, who obtained a grant to completely restore and rebuild the organ as near to its original condition as possible. Wurlitzer theatre organs were manufactured between 1911 and 1942. The Town Hall currently houses government and administrative functions.

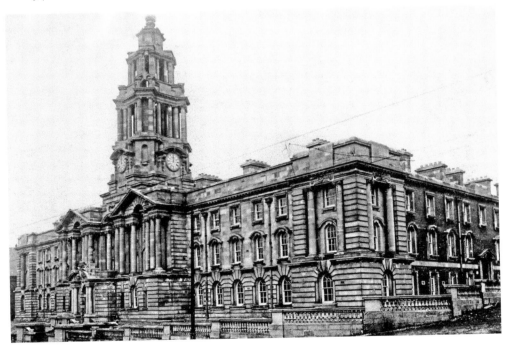

The Town Hall.

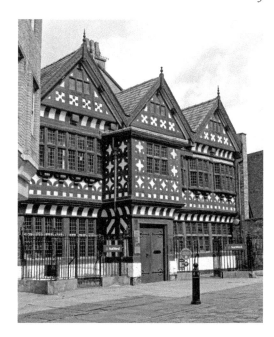

Underbank Hall.

Underbank Hall

Underbank Hall is a fifteenth-century Grade II-listed building. It was originally a town house for the Arden family of Bredbury. William Arden (1789–1849) was a British army officer in the Coldstream Guards and a socialite within the Prince Regent's circle. The hall was sold by auction in 1823 and the Bredbury estate sold in lots in 1825 to pay off William Arden's debts. A bank has been on the site since 1824 when the Manchester & Liverpool District Bank opened. A banking hall was added in 1919. The hall is now a branch of the National Westminster Bank.

Stockport War Memorial Art Gallery

The foundation stone was laid on Saturday 15 September 1923 by Charles Royle JP, alderman and mayor of Stockport. The Stockport War Memorial was then opened by Prince Henry on 15 October 1925 and serves as a lasting reminder of those who lost their lives during the First World War. Tablets were added in 1952 bearing the names of those who lost their lives during the Second World War and additional tablets have been added to commemorate those who have 'lost their lives in the service of the Crown since 1945'. An inscription above the entrance reads: 'In Memory of the people of Stockport who fell in the Great War (1914–1918).'

The entrance hall is supported by two cipollino (Greek) marble columns. The walls are faced with Marzano Botticino (Italian) marble with green Tinos (Greek) marble skirting and frieze, and the floor is of Hauteville and Belgian black marble. Gilbert Ledward of London created the magnificent sculpture in white Italian marble, and it symbolises 'the idea of sacrifice and devotion of those who fell in the War'. The sculpture rises to a total height of 11 feet and is lit from above by a glass dome roof. Stockport Grammar School was previously housed on the site in a building that had been opened on 30 April 1832, having

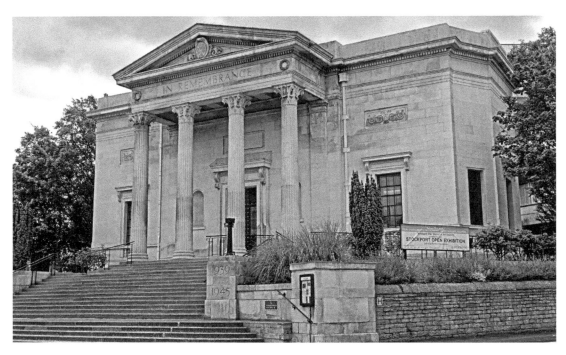

Above and below: Stockport War Memorial Art Gallery.

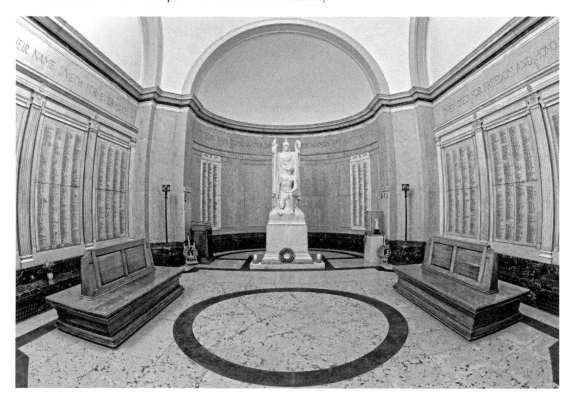

been moved from premises in Chestergate. The school had been in Chestergate since its formation in 1487. The building contains two art gallery spaces and a memorial hall on the ground floor, with further gallery space upstairs. The art gallery is a vibrant, contemporary art space and hosts regular exhibitions in all four of its galleries. The gallery gives emerging artists a chance to showcase their work and has a long history of exhibitions from some of the art world's finest artists. It was Grade II listed in 2007.

St Petersgate Bridge

St Petersgate Bridge, a road bridge over Little Underbank, was built to improve the accessibility to the Market Place and the Market Hall; it also has pedestrian steps on either side, linking the upper and lower streets. It was built between 1866 and 1868, opening in February 1868 in what was considered to be a technically challenging urban location. The designer was R. Rawlinson and the engineer was Brierley of Blackburn. The bridge, now Grade II listed, has some interesting features: five cast-iron arches, cast-iron signs with pointing hands and relief lettering, and a plaque bearing the borough's coat of arms.

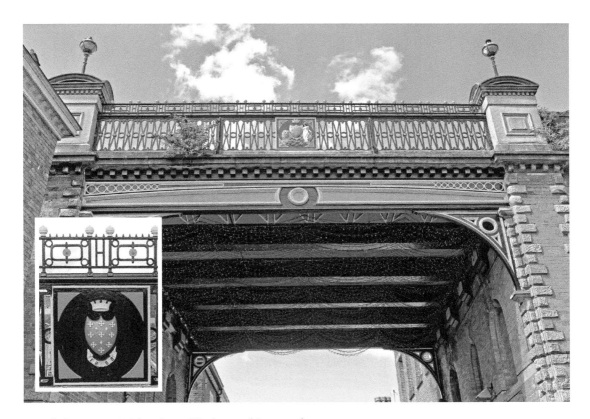

St Petersgate Bridge. *Inset*: The borough's coat of arms.

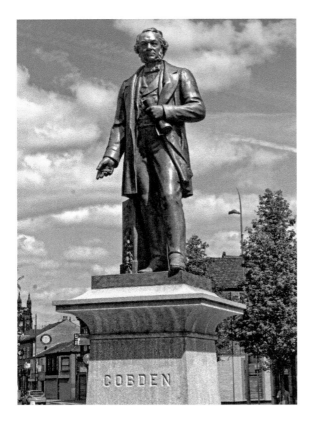

The statue of Richard Cobden.

Richard Cobden

Richard Cobden was born in West Sussex in 1804 and spent much of his life in poverty before eventually making his first visit to Manchester in 1825, where he worked as a commercial traveller. By 1832 he ran a successful calico printing business and was living on Quay Street. Cobden was an influential figure in Manchester life and instrumental in the foundation of the Athenaeum. He led Manchester's campaign against the Corn Laws, founding the Anti-Corn League, and was also passionate about the abolition of slavery. In his roles as MP for Stockport and the West Riding of Yorkshire, he made many anti-slavery speeches in Parliament. He died on 2 April 1865, a week before the Confederate surrender and twelve days before the assassination of Abraham Lincoln.

Stockport Viaduct

The River Mersey passes underneath Stockport's most distinctive landmark after leaving the Merseyway Shopping Centre. The Stockport Viaduct is one of the largest brick structures in Britain and features in the background of many L. S. Lowry paintings. It was built between 1839 and 1840 to carry the tracks for the Manchester & Birmingham Railway over the River Mersey and is still in use today. At the time of its construction, it was the largest viaduct in the world. The architect was John Lowe and the engineer was George Watson Buck. The level structure rises 39 metres above the riverbed, is 539 metres long and was originally 9.45 metres wide. It has twenty-seven semi-circular arches with a 9.2 metre span, in addition to four small arches (two at each end) and twenty-two main arches with a 19.2 metre span. An extra side arch was added in 1888 due to the widening of the viaduct. The viaduct cost £72,000 to build and is reputed to contain 11 million bricks and 11,300 cubic metres of stone. The line from Manchester to Stockport opened on 4 June 1840, and the viaduct was completed on 21 December of that year with two tracks. It was widened to accommodate two further tracks during 1887–89. The first locomotive passed over it on 16 July 1841, followed by rail traffic from 10 August 1842. The viaduct gained Grade II* listing on 10 March 1975. Each of the three-lane carriageways of the M60 Stockport bypass (originally the M63 and constructed in 1979–82) passes under a single arch of the viaduct. In 1989, the viaduct was cleaned and floodlighting installed during a £3-million restoration project.

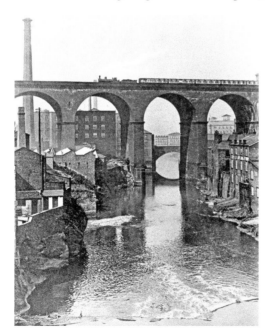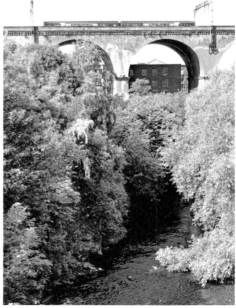

The viaduct then and now

The River Mersey Starts

The River Mersey springs to life at the confluence of the rivers Goyt and Tame. Sandwiched between the concrete retaining walls of the M60 and the delivery entrance to a local supermarket, it is hidden away from the casual observer. However, it is marked by an impressive, wrought-iron sculpture, which lyrically claims, 'Water is Life and Heaven's Gift. Here Rivers Goyt and Tame Become Mersey. Flowing Clear From Stockport to the Sea.' The sculpture was placed here in 1994 as part of a project by Mind Stockport, in association with the residents of the local Lancashire Hill district; the piece incorporates artistic images that relate to Stockport's history and heritage. There are images of Victorian mills, local wildlife, a fisherman, a footballer and an aeroplane. Stockport has long stood on the incoming flight path for Manchester Airport, but it would be nice to think that, in part, the artwork remembers the seventy-two people killed in the Stockport air disaster of 1967.

The merging point of the two rivers has been practically inaccessible since the building of the M60 ring road and the associated alterations to the road structure around Stockport town centre. Prior to these modern developments, the two feeder rivers would have meandered through Stockport's mill land and celebrated their transformation into the Mersey at the open land surrounding the old cobbled bridge on Howard Street.

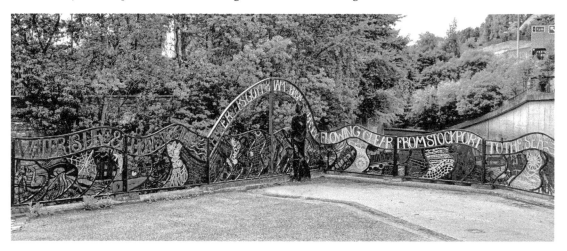

The start of the River Mersey is marked by an impressive wrought-iron sculpture.

Merseyway and Stockport Town Centre

The rivers Goyt and Tame form the River Mersey just before entering Stockport but it disappears almost immediately under the Merseyway shopping precinct, which has encased the waters and steep-sided banks since its completion in the mid-1960s. Here, the River Mersey then starts its 110-kilometer journey to the sea. The main commercial area of Stockport is the town centre, with branches of most high street stores are found in the Merseyway Shopping Centre (or the Peel Centre, which lays a few hundred metres away from the main town). The name Merseyway comes from the fact that it is built on giant stilts above the River Mersey, with the river running under the entire length of the centre. It was one of the first shopping centres to open in 1965 and was refurbished in 1995. In 2001 there were plans to fit glass panels into the pavement within the centre to reveal the River Mersey underneath; this was to try to boost tourism in the town by providing spectacular views of the river swirling beneath the shoppers' feet. The centre and Stockport's shopping area attract around 14 million visitors per year, making it a popular shopping destination in the Greater Manchester urban area. The main shopping street in 1908 was called Heaton Lane but it was renamed Prince's Street following the royal opening of the Town Hall.

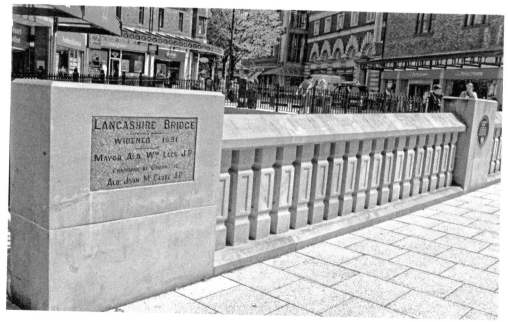

Lancashire Bridge, first mentioned in 1282, is located in the town centre and was an important crossing point between Cheshire and Lancashire before Wellington Bridge was built 1824–26. The current Lancashire Bridge dates from 1891, however a recent restoration programme was completed in July 2015 and the bridge was officially opened by Councillor Andrew Verdeille, mayor of Stockport.

The Plaza

The Plaza was built on the site of some former cottages adjoining the Lawrence Street steps, built in 1929. It was a particularly difficult cinema to build due to the sandstone cliff at the rear of the building, from which 10,000 tons of rock had to be quarried to a depth of 42 feet. The building had to be adapted around the limitations of the site, notwithstanding the bold, towering faience-tiled façade, which dominates Mersey Square. The architect was William Thornley, who practised in Manchester and Wigan and was responsible for around fifteen cinemas in what is now called Greater Manchester. As with other super cinemas, the whole concept behind the Plaza was to create luxurious, uplifting and literally fantastic surroundings to complement the dream-like experience of film entertainment and provide effective recreation for people accustomed to the hard life of a northern industrial town. In the Plaza, this was achieved using neoclassical, Egyptian, Moorish and art deco architectural influences, illuminated by a Holophane lighting system that employed approximately 6,000 bulbs around the auditorium. The opening show at the Plaza took place on Friday 7 October 1932 and featured the films *Jailbirds* starring Laurel and Hardy, and *Out of the Blue* with Gene Gerrard and Jessie Matthews, along with the resident organist Cecil Chadwick at the Mighty Compton Organ. Admission prices were 7d for the cheapest stalls seats. The Plaza's bill of entertainment was complimented by the café restaurant, open for morning coffee until the evening.

Nothing like the Plaza had been seen in Stockport before and its success was proven by the profits in excess of £5,000 in the first year. By the mid-1930s the Plaza was mostly showing films and its success led to competition from more new cinemas in the district, with no less than 8,400 seats being added in five new cinemas between 1937 and 1939. All are now demolished. The Plaza's auditorium was showing signs of wear and tear by the post-war years but was refurbished in the early 1950s. In this decade it was a particularly well-run house, operating successfully against competition from the two nearest large cinemas (the Ritz and Essoldo) and had the benefit of being on national circuits with access to high-quality films. The Plaza itself showed Stockport's first 3D film (*Sangaree*) in 1953, and some of the Cinemascope epics of the period including *The Ten Commandments*, *Bridge on the River Kwai* and *South Pacific*. Live singers and the organ were again featured, mainly at weekends, along with the occasional skiffle group, big band and Sunday jazz concerts with such musicians as Ronnie Aldrich, Johnny Dankworth, and Cleo Lane. In the 1960s the café was a popular haunt for the town's younger people. Films were suspended at Christmas 1960 to allow the pantomime *Babes in the Wood* to be held on stage, starring the Dallas Boys. The Plaza had served Stockport's entertainment needs well, but in 1965 it was sold to the Mecca group for conversion to a bingo hall. The Mighty Compton Organ has been used since the opening of the Plaza in 1932.

The Plaza closed as a cinema on 31 December 1966; the films on show were *Three on a Couch*, starring Jerry Lewis, and *The Texican* with Audie Murphy and William Star at the organ. It reopened as a bingo hall on 6 February 1967 and soon became one of the

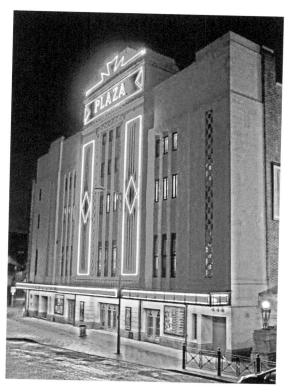

The Plaza is Stockport's Super Cinema and Variety Theatre.

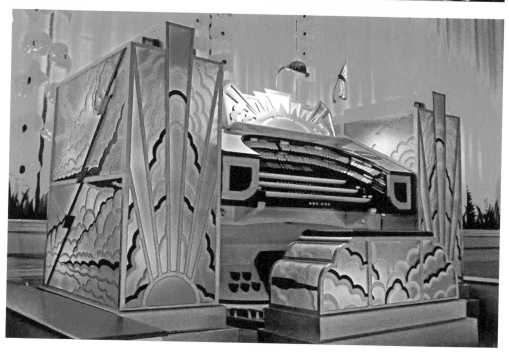

The mighty Compton Organ has been used since the opening of the Plaza in 1932.

most successful in the area. At one stage a nightclub called Samantha's was operated in the former café area. By the time the Plaza became one of the last Greater Manchester's traditional bingo halls, the decision was taken to close on 23 August 1998; there was a commemorative farewell event, including Michael Holmes at the Compton Organ, which had remarkably survived in working order. The Plaza had been Grade II listed by English Heritage by then and was the only building in the Borough of Stockport still capable of full-scale theatre and entertainment use. The Plaza had been identified as the best surviving super cinema auditorium in the north of England, and it was on its closure that a remarkable combination of circumstances was to take a hand. In 2000 the Stockport Plaza Trust, a charitable trust formed to save, protect and operate the Plaza, reopened the venue with a dedicated team of volunteers and a few paid staff. In subsequent years they raised over £3 million for the first stage of the Plaza restoration, and assist in operating the Plaza to this day in its original capacity as the finest super cinema and variety theatre in the region.

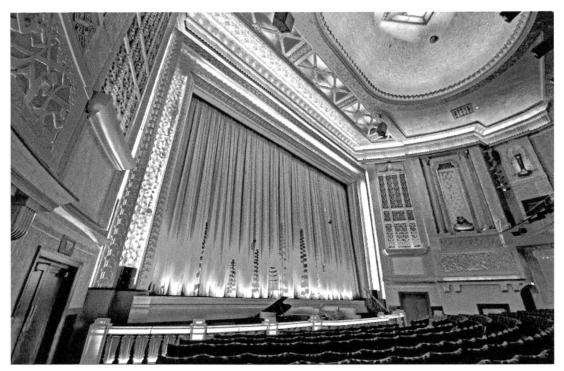

The Plaza is one of the finest super cinema and variety theatres in the region.

Robinsons Visitors Centre

Here, visitors could see the old with the new as they explored the brewing process. Visitors are educated and entertained on their journey around the brewery with a helpful guide. The brewery tour takes around an hour and includes small samples of beers.

Robinsons' Visit England accredited visitors centre reveals the secrets behind their award-winning brewing process and provides insights into the original and new equipment. As visitors journey through the brewhouse, they will learn: how Robinsons select the ingredients that produce the distinctive tastes and aromas of 'Robbies' ales, the science and technical information behind the brewing process' and what makes the hopnik and cereal cooker so special and why it's so important in brewing Robinsons beer.

Robinsons Public Houses

Today, with 280 public houses across Cheshire, Derbyshire, Lancashire, Cumbria and north Wales, the Robinsons family is part of the local landscape. Here we look at just a few.

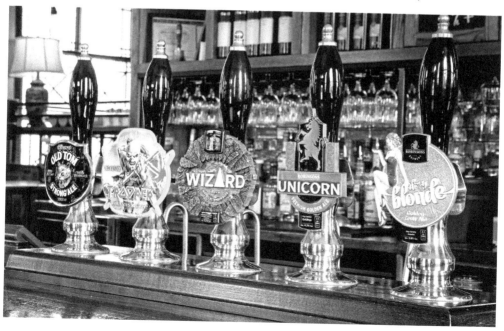

A fine range of beers is standard in all Robinsons public houses.

The Blossoms

Just south of Stockport town centre is The Blossoms, a historic landmark pub that was originally a Bells pub (where the annual company meetings for Bell's Brewery were held). Due to its corner location, this Grade II-listed former coaching house has an unusual triangular shape. It has survived unscathed from the fashion of the open-plan pubs in the late twentieth century. The Blossoms retains its original small intimate rooms, central curved bar and a good sized first-floor function room, home to a number of societies and well used for local functions. Cask beer is the main feature of The Blossoms; there is a wide range available, including the ever-changing limited edition range of seasonal beers from Robinsons. The Blossoms is the perfect place to unwind.

The first of the front rooms boasts many details of the now defunct Bells Brewery, which sat on nearby Hempshaw Lane, from share certificates and posters to old newspaper articles. The next front room has an impressive display of pewter tankards against a backdrop of wallpaper designed with images of Robinsons famous Old Tom bottled beers. The back room has many interesting photos of old Stockport and the brewery.

The Blossoms has a welcoming community feel and an extensive range of beers that stand out in this Robinsons pub. The pub has eight cask ales on offer from the Robinsons range in addition to a comprehensive craft beer menu of bottled beers from America, Belgium, and Germany.

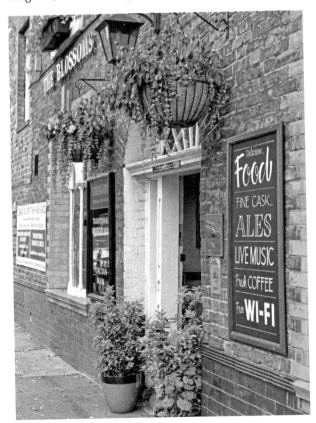

More recently, the popular English indie pop band 'Blossoms', from Stockport, announced that their band was named after this local pub.

The Arden Arms, Millgate

The Arden is an early nineteenth-century coaching inn set on the edge of Stockport's historic Market Place. The *Good Beer Guide*, published by the Campaign for Real Ale (CAMRA), describes the pub as 'Grade II listed and warranting a visit for the building alone.' It continues: 'Note the fine bar, tiled lobby, grandfather clock and splendid snug.' The Arden features traditional hand-pulled beers from Stockport's Robinsons Brewery, along with a significant range of wine, spirits, liqueurs and soft drinks. The inn has won a number of awards in the past few years: it was voted Greater Manchester's 'Regional Pub of the Year' in the 32nd edition of the *Good Beer Guide*; it came runner-up in the National Competition in 2004, placing it in the top four pubs in Britain; and the Arden was declared 'Pub of the Year' for 2008/09 as part of the Manchester Food & Drink Festival.

The pub itself has a fascinating past. The land on which the present Arden Arms stands was originally a market garden owned by the Raffald family, who had been florists, gardeners and seedsmen in Stockport since the sixteenth century. The garden was put to several commercial uses besides cultivation. There are records of a livestock market, a corn mill and also an inn, the Blue Stoops, built in 1650. The name 'stoops', or 'scoops', has a meaning of 'cup'.

In 1760, John Raffald handed ownership of the garden to his brother, George Snr, and took up the position of head gardener at Arley Hall in Cheshire. It was here that he met Elisabeth Raffald and married her in 1763. Elisabeth later wrote one of England's earliest

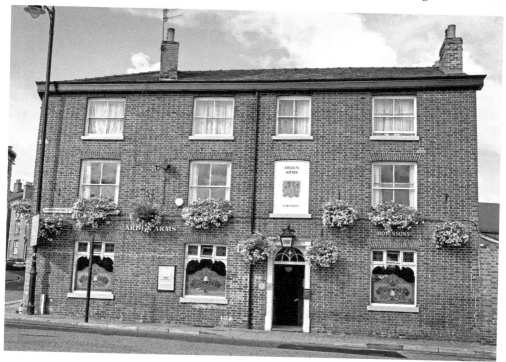

The Arden Arms.

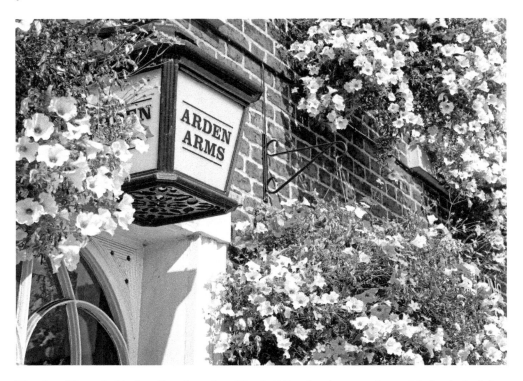

The *Good Beer Guide* describes the pub as 'Grade II listed and warranting a visit for the building alone,' although it's well worth staying for a pint and a spot of lunch or dinner as well!

and most famous cookbooks *The Experienced English Housekeeper*. It was John and Elisabeth's nephew, George Raffald Jr, who built the present Arden Arms pub in 1815 on the site of the Blue Stoops.

The brand new Arden Arms was constructed in the contemporary late Georgian style. A print of Millgate in the mid-nineteenth century, reproduced in Heginbotham's *History of Stockport*, shows the pub looking distinctly modern compared to the thatched dwellings on the opposite side of the road. The Arden was bought by Robinsons Brewery in 1889, and in 1908 they set about the first, and last, major renovation of the pub. The scheme involved the construction of the stable courtyard to the rear and side of the building, alterations to the ground-floor windows, and interior work to create bench seating in the snug and vault. It remains like this today, save for the building of two small extensions at the rear of the house – inside toilets and a catering kitchen. The interior of the pub is included in the CAMRA National Inventory, a list compiled by the lobbying group of the only remaining 250 pub interiors (out of over 60,000) in Great Britain that remain of outstanding heritage interest.

The Arden has a classic multi-roomed layout, complete with a fine curved wooden bar, original tiled floors, and a tiny snug that can only be reached upon invitation through the bar. Outside is the cobbled courtyard, which is now a beer garden. If you visit often enough, you may be given the opportunity to go down the steep stairs to the cellar to visit the mortuary slabs, a testament to the time when inquests were held at this historic pub.

Robinsons Shire Horses

Hopnik and Wizard are Robinsons' shire horses. They are the latest in a long line and apart from a brief interruption during the First World War, when all horses were sold for war duties, have served Robinsons Brewery for over 100 years. In the heyday of the shire horse, before the arrival of the internal combustion engine, Robinsons shires were in the main brewery yard working every day to deliver the company's brewed ales to local inns and hostelries. Despite this, their primary use was moving bottles and cases between the Unicorn and Hempshaw Brook Breweries in the 1950s. Shires also moved cinders from the main yard, spent hops and waste paper.

Hopnik and Wizard are two of the few remaining working shires in the British brewing industry. These horses are a familiar and much-loved part of Stockport's heritage; the sight of the Robinsons shires evokes happy memories of a bygone time. Today, Hopnik and Wizard make guest appearances at Robinsons trade shows, promotional events, anniversaries, pub openings and notable celebrations. They can also be found at a range of shows, carnivals and country fairs throughout the year – winning many prizes for their immaculate turnout, grooming and show discipline.

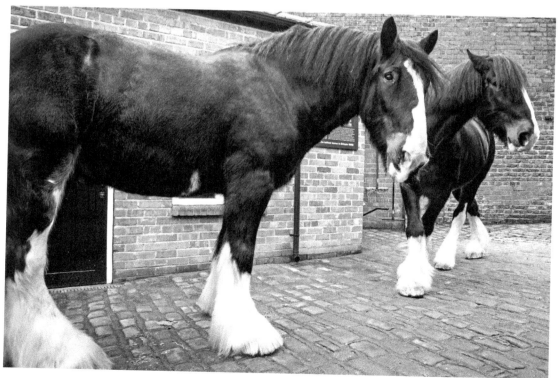

Hopnik and Wizard.

The Heatons Red Cross Hospitals and the First World War 1914–18

Standing high on a pedestal outside St John's Church, on Heaton Moor Road, is a shining bronze statue of a soldier in battle dress. Its bronze panels record the names of those from the Heatons who died during the First World War.

The statue was designed by Manchester sculptor John Cassidy, with the original estimate of the cost being £1,800–£2,000. The completed memorial was unveiled in January 1922 and Cassidy agreed not to use the same model for any other memorial within a 30-mile radius.

Many Stopfordians, however, did return, often on casualty trains, which carried the injured back from the front to be looked after in the safety of their home town. The sheer volume of casualties meant that the existing hospitals could not cope with the volume of men being returned from the front, so temporary Red Cross hospitals were set up to support the medical services. The Heatons had two such hospitals ready to receive its wounded heroes, which were situated in the Reform Club on Heaton Moor Road, and in the Methodist Church Hall on Cavendish Road.

Each night the male volunteers would travel to Stockport or Heaton Mersey Station to meet the trains and load the stretcher cases into waiting ambulances. They often stayed all night, leaving at 6.00 a.m. and getting home for just an hour's rest, before getting the train to work into Manchester.

The vast majority of the work in the wards was done by the female volunteers who rolled bandages, made shirts, knitted clothes and helped to run the hospital canteens. They cleaned and washed the hospital uniforms, which were bright blue, and wheeled the men out into the sunshine on bright days to recover in the clean, fresh air of the village.

The front-line nursing was carried out by VADs (Voluntary Aid Detachment nurses) who ran the wards and supported doctors in administering treatment to wounds, as well as implementing recuperation programmes.

There are officially fifty-three 'Thankful Villages' in the UK; settlements in both England and Wales (none in Scotland or Ireland) from which all local members of the armed forces survived the First World War. As such, they have no war memorials and no losses to mourn – all their men came home again. This was not the case in the Heatons or in other areas of Stockport. Cassidy's memorial contains the names of 126 men and one woman who lost their lives in the conflict, a symbol of how, in the majority of cities, towns and villages, all members of the community were in some way touched by the unforgettable events unfolding in those foreign fields.

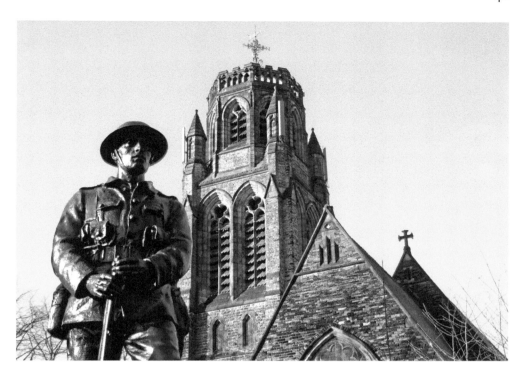

The war memorial on Heaton Moor Road contains the name of one woman, a nurse, Gertrude Powicke, the only woman on any war memorial in Stockport. She grew up in a very religious and scholarly family in Stockport and was an active supporter of the Suffrage cause. In 1919, Gertrude travelled to Poland with the Friends' War Victims Relief Committee in order to treat an outbreak of typhus. Sadly, she contracted the disease herself and died on 20 December 1919. She was buried in the Evangelical Reformed cemetery in Warsaw.

Walter Brownsword, a retired teacher who helped with the repatriation of injured soldiers, was a great believer in the power of recreational therapy.

Outside the Town Centre

Stockport Armoury

In 1859 a Royal Commission recommended the protection of Britain's main dockyards and some inland sites as a result of France trying to revive itself as an empire. At this time, France had immense territorial ambitions under Napolean III. However, by 1862 newspapers were stating, 'volunteering still goes on in many places, but less as a matter of panic than a matter of pastime!' Stockport Armoury was built in 1860 and opened in 1862 to house the Stockport Regiment, which became the 4th Cheshire Battalion Rifle Volunteers, set up to defend the town against an invasion from the French, under Napolean III. The Battalion and the Armoury were both funded by the people and 'Gentlemen' of Stockport. The architect was H. Bowman. The Grade II-listed building consists mainly of an octagonal tower in red brick with pointed copper and ashlar rusticated quoins and cornice.

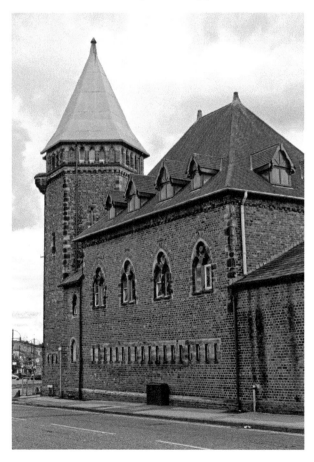

Stockport Armoury was built in 1860 and opened in 1862. It is now a Grade II-listed building.

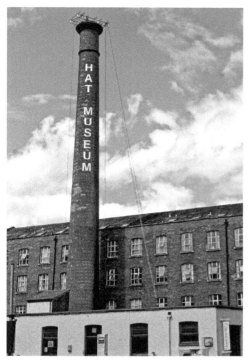
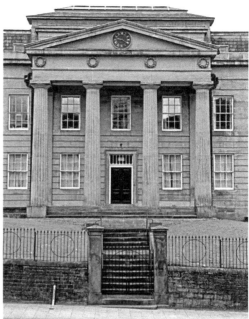

Above left: The Hat Works Museum.

Above right: Stockport Infirmary.

The Hat Works Museum

Stockport, being famous for its hat-making industry, now has the UK's only museum dedicated to hats and hat-making. It is housed in the seven-storey brick building that is Grade II listed. Wellington Mill, built between 1830 and 1831, was originally a cotton spinning mill and became a hat works during the 1890s. The mill was designed by Thomas Marsland and was one of the early mills to have a fireproof cast-iron structure. The chimney, which is 61 metres high, was added in 1860.

Stockport Infirmary

Stockport Infirmary was built on land that was donated by Frances Maria Warren (Lady Vernon) during the period 1832–33. The building, which is now Grade II listed, was constructed in the Greek Doric style by the architect and surveyor Richard Lane. It opened in July 1833 and was extended in 1900, 1914 and 1938; it ceased to be a hospital in April 1996. It replaced the Dispensary and House of Recovery, which was opened in 1792. The infirmary was considered for royal status following the medical work and care that was carried out during and after the Stockport air disaster in 1967. The building, now called Millennium House, is used by the government's pension service.

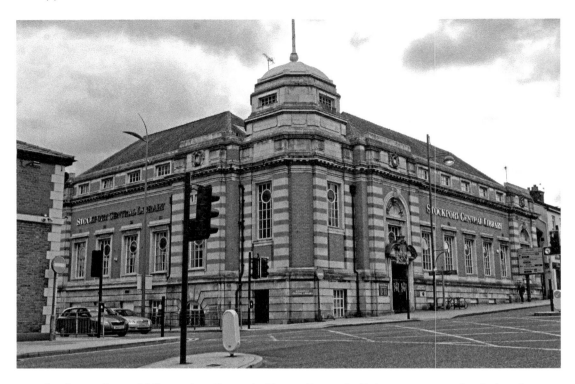

Stockport Central Library is a Carnegie library. It was built in 1913–15 to the designs by Bradshaw, Gass & Hope in the Edwardian baroque style with a prominent corner dome and tall finial.

Central Library

Central Library is an Edwardian baroque-style red brick and Portland stone building and situated on the corner of St Petersgate and Wellington Road South. It was built between 1913 and 1915 at a final cost of £15,000 by Bradshaw, Gass & Hope. The wealthy American Andrew Carnegie covered the cost of the building. He endowed over 600 libraries in Britain and many more worldwide during the late nineteenth and early twentieth centuries. The inside design has a glazed dome that is supported by Ionic columns and stained-glass windows showing the names of writers. The Public Libraries Act of 1850 allowed Stockport Borough to fund a public library, so in 1875 Stockport's first library opened in a room above the Farm Produce Hall (or Cheese Hall) in the Market Place.

Fred Perry and Fred Perry Way

Fred Perry (18 May 1909 – 2 February 1995) was born on Carrington Road, Portwood, Stockport. A Metropolitan Borough of Stockport blue plaque is displayed on the house and a silver tea service, which was awarded to him in 1934, is on display in the Stockport Story Museum. Fred lived in the North West of England for the first ten years of his life, before the family moved to the London area as a result of his father's involvement with local politics.

He was one of Britain's greatest tennis players and sportsmen, winning ten major championships, including eight Grand Slam titles: three consecutive Wimbledon Championships 1934–36; the Australian Open 1934; the French Open 1935; and the US Open 1933, 1934 and 1936. He also led Great Britain to four consecutive Davis Cup victories in 1933–36. Fred was made a Freeman of Stockport Borough in 1934 to honour his sporting achievements and turned professional in 1936, and moved to America following his many successes in the amateur game. He had a No. 1 world ranking in 1934 and entered the International Tennis Hall of Fame in 1975. He launched his own clothing range during the 1950s with the Fred Perry shirt becoming very popular.

Fred Perry's early life in Stockport is remembered in a walk opened by Stockport Borough Council in 2002. The Fred Perry Way is a 23-kilometre walk that spans Stockport Borough from Woodford in the south to Reddish in the north. It passes through the Portwood area, where he spent part of his childhood, and part of Happy Valley and combines rural footpaths, quiet lanes and river valleys with urban landscapes and parklands.

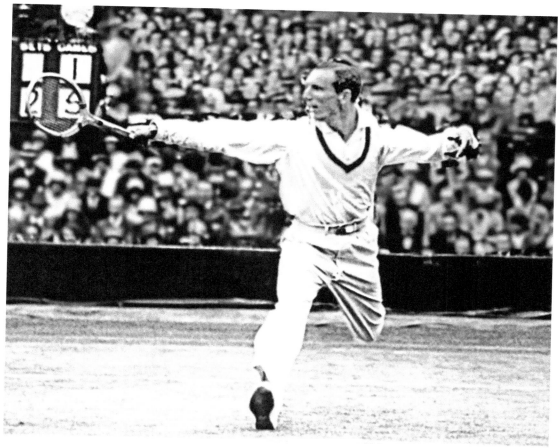

Fred Perry was born in Stockport. He was one of Britain's greatest tennis players, winning eight Grand Slam titles.

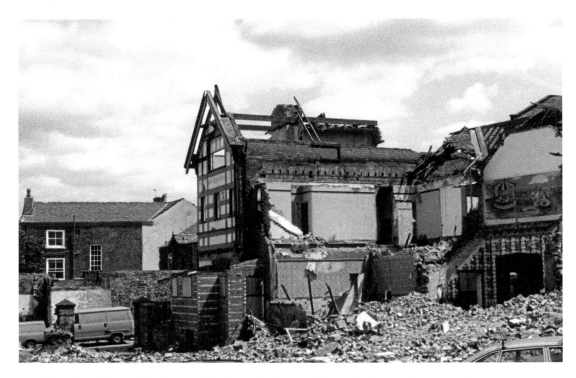

The demolition of the County Hotel revealed some of Lowndes impressive artwork.

Alan Lowndes

Alan Lowndes was born in Heaton Norris in 1921 and was the fifth son of a railway clerk. He left school at the age of fourteen, taking a job as an apprentice to a decorator. As a young man he joined the armed forces, where he saw active service in the Middle East and Italy during the Second World War. At the end of the war he returned to Stockport and studied art at night school, painting scenes of northern life in a style reminiscent of Lowry. He often painted murals; some of his work was unveiled during the demolition of the County Hotel on Millgate during the 1980s, now the site of ASDA. Sadly, the building was demolished before the works could be saved – the building was reduced to rubble over one weekend when appeals were in process to save the paintings. During his lifetime he had a number of one-man exhibitions in Manchester, London, and New York, and today his work is represented in many private collections. He died in Gloucestershire in 1978, aged fifty-seven.

Samuel Oldknow

There can be few people who have had such an impact on the industrial development of the town as Samuel Oldknow. He was born in Anderton, Lancashire, in 1756. In 1784, after serving an apprenticeship in his uncle's drapery business in Nottingham, he made a decision to join the great cotton boom and moved to Stockport where he bought a house and warehouse on Upper Hillgate, establishing a cotton mill for the manufacture of muslin.

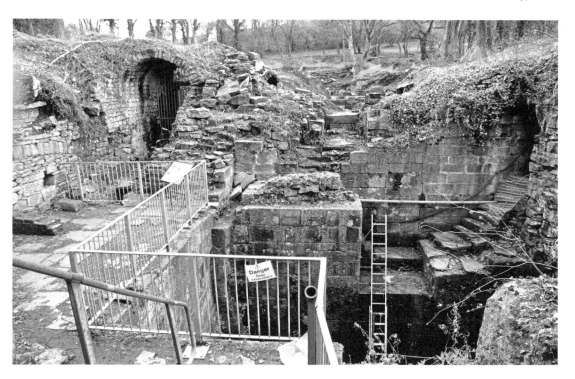

The excavation of Samuel Oldknow's mill and the surrounding area give a clear indication of the size and complexity of Mellor Mill.

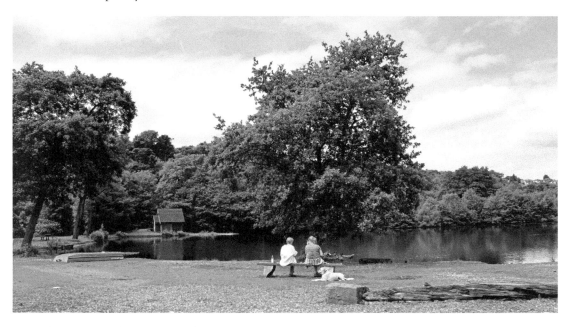

The Roman Lakes are a popular tourist attraction set in a tranquil valley between the outskirts of Marple and Mellor Village.

By 1786 he had become one of the foremost muslin manufacturers in the country and his holdings in Stockport had expanded to include a steam-powered spinning factory, a smaller factory at the Carrs, to the west of Churchgate, a bleaching plant at Heaton Mersey, and finishing factories at Bullock Smithy and Waterside in Disley. On the road from Marple to the Roman Lakes, the site of his magnificent cotton mill and private mansion, Mellor Lodge, are currently undergoing a programme of excavation.

It was in 1787 that Oldknow began to purchase large areas of land around Mellor, including the Bottoms Hall Estate where he built his first mill in 1790, just south of Marple Bridge. The Mellor Mill was a six-story brick building, which, at the time, was the world's largest spinning mill. As part of its construction the River Goyt was diverted, three millponds were created, and a system of tunnels, channels and wheel pits were built. The millponds still remain to this day and are called the Roman Lakes. They were given the name in Victorian times and subsequently became a huge tourist attraction.

Oldknow was an ambitious man of his age and was always ready to develop new ventures. He became the driving force behind a number of projects: the building of the Peak Forest Canal; constructing the Gothic-inspired lime kilns in Marple; running a fleet of narrow boats; constructing a warehouse and wharf; and working with Outram and Brown on their greatest surviving monument, the Marple Aqueduct.

The Roman Lakes are particularly attractive in springtime.

Vernon Park

Vernon Park, also known as 'The People's Park', is Stockport's oldest public park, named in honour of Lord Vernon – George John Warren, former Lord Mayor of Stockport. In 1844 he donated 10 acres of land known as 'Stringers Fields' and a further 11 acres were purchased from Samuel Howard Cheetham, a Stockport surgeon, in 1851. Work didn't start until 1857, but it only took a further eight months to prepare the 21 acres for opening on 20 September 1858. Most of the park was built by hungry unemployed men who were grateful for the opportunity to work, so the park originally had the nickname of 'Pinch Belly Park'. The park is an exceptional Victorian/Edwardian park, which is well used by schools for historical and environmental studies. It has Grade II status on the Historical Parks and Gardens register because it has many special features, including historical plant collections, a cannon, water cascades, a museum and a traditional carved cast-iron and stone main entrance gateway. The site boasts mature woodland along the river terraces, which is being sensitively managed while maintaining public access. The park has also been awarded the Green Flag Award, an honour that recognises excellence in recreational green areas.

The inscription above the entrance to the museum reads: 'Erected and Presented to the Inhabitants of the Borough of Stockport by its Parliamentary Representatives James Kershaw and John B. Smith'. In the late eighteenth century there was an expansion in

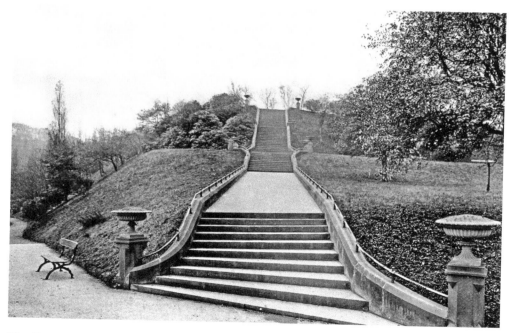

The 'Steps' in Vernon Park, c. 1900, link the lower part of the park to the area around the museum.

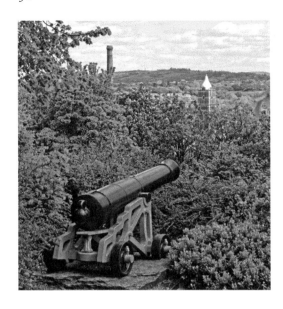

The cannon, in the foreground of the photograph, is a cast-iron Blomedfield 24 pounder and the mill in the background is Pear New Mill.

cotton processing in and around Stockport and Manchester. The rivers Goyt, Mersey, Tame, and Etherow provided the mills with a good supply of water. There, many people used to working in the silk-weaving industry, so Stockport was well placed to take advantage of this expansion. Pear New Mill began producing cotton in July 1913 so became one of the last cotton mills to be built in England. The Grade II*-listed Edwardian building lies on the northern bank of the River Goyt. The large six-storey mill, with a steel frame and cast-iron columns, was built by Stott & Sons and completed by P. S. Stott. Textile manufacture ceased operation in March 1978.

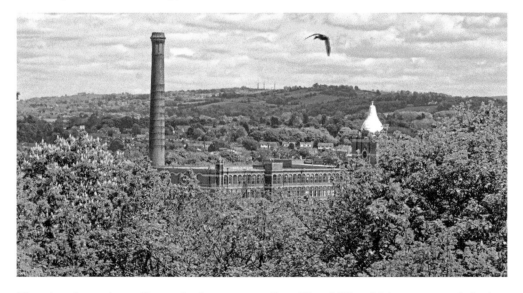

The view from the café area looks out onto Pear New Mill, which was one of the last cotton-spinning mills to be built in England.

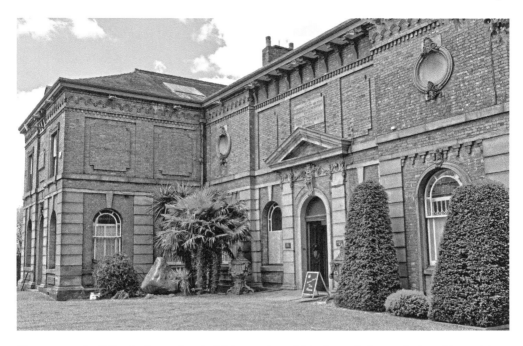

The museum building is situated at the highest point within the park. It was designed by architect Alexander Mills in 1860 and is now a Grade II-listed building.

The park has Grade II status on the Historical Parks and Gardens register because of its many features. It is located just outside the busy town centre and is a tranquil place to walk, rest or have a coffee in the café.

Stockport County Football Club

Stockport County Football Club was formed in 1883 as Heaton Norris Rovers, with their home being the Nursery Inn, Green Lane, Heaton Norris, playing games there from 1889 to 1902. The name was changed in 1890 to Stockport County and the team moved its headquarters to Edgeley Park in 1902. Stockport County are called 'The Hatters' after the town's involvement with the hat-making industry or locally known as 'County'. The team have spent most of their history in the lower reaches of the Football League. However, they did have five seasons in the First Division (now known as the Championship) during the late 1990s and early 2000s, following their automatic promotion by finishing second to Bury during the 1996/7 season with 82 points. This was a magnificent season for County as they managed to also reach the semi-final of the Football League Cup, beating three Premiership teams along the way: third round against Blackburn Rovers, fourth round against West Ham United, and the quarter final against Southampton, eventually losing 2-1 over two legs to another Premiership team, Middlesbrough.

One claim to fame for County is that George Best was never on the losing side when he played for Stockport County during the 1975/76 season. County were then in the 'old' Fourth Division at the time. Admittedly, he only played three games: against Swansea, where they won 3-2; against Watford, where they drew 2-2; and against Southport, where they won 1-0. Best scored two goals, one each against Swansea and Watford during November 1975.

Other records held by County include: in 1901 Arthur Wharton became the first black professional footballer; in 1934 they beat Halifax Town 13-0 in Division Three North to record the League's highest victory; and in 2007 they won nine consecutive league games without conceding a goal. A number of players have been capped in full international (A) matches while registered with County. More recently, these have been: Peter Thompson (Northern Ireland, 2008), Ashley Williams (Wales, 2008), Danny Griffin (Northern Ireland, 2004), Jim Goodwin (Republic of Ireland, 2002) and Harry Hardy (England, 1924). The photograph shows the 'Cheadle End', the home supporters' side located at the west end of the ground, opened in 1995 – a two-tiered stand with a capacity for over 5,000 supporters. The stadium has an overall capacity for 10,900 spectators.

County's strip during the 2015/16 season consisted of blue shirts, white shorts, and white socks with a blue hoop around the top. However, there have been a number of different designs used throughout the decades; in fact, it is stated in football history books that the colours used during the 1890s were red and white. The strip at that time was made up of a red and white striped shirt, long white shorts and dark navy socks. The present Stockport County FC crest was introduced in 2015 and shows both Stockport Castle, which stood until 1775, and the blue shield, which is taken from the coat of arms of the de Stokeport family, from which Stockport derives its name. The name of the football club and the year it was formed is now the only writing on the crest.

The ground in Edgeley was built in 1901 for a rugby league club; however, by 1902 the club had disbanded, leaving the ground empty. County at this time were looking to find a larger ground, having outgrown the space at the Nursery Inn. Rugby did return to the stadium when Sale Sharks Rugby Union Club shared the ground with County between 2003 and 2012.

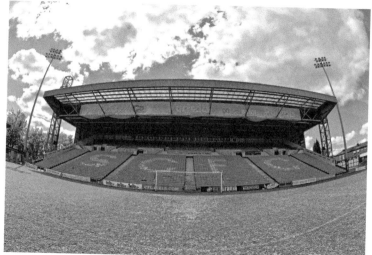

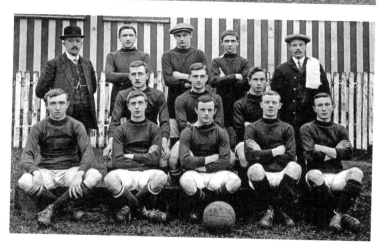

Heaton Norris Rovers team photo, taken pre-1890.

The A6 (Wellington Road) – The Country's First Town Bypass.

An important point in the history of the A6 can be traced back to the turnpike era and the establishment of the Highways Act of 1555. Before the introduction of this act, the management of roads and responsibility for their upkeep was in the hands the owners of the road or the parish, and most roads were not suitable for the regular conveyance of heavy goods. The establishment of the Manchester and Buxton Turnpike Trust in 1725 allowed for the raising of money to improve roads on specific routes and the main Manchester to London route through the town was established as the area's first turnpike. The route followed the old Roman road from Heaton Chapel, down Manchester Road towards the top of Lancashire Hill and down Dodge Hill to Lancashire Bridge. It then proceeded through Underbank and along the Hillgates to the southern toll point at the Blossoms Hotel.

The narrow streets and steep hills around the centre of the town required that a solution be found to cope with the steadily increasing traffic and so a more direct route, from the turning at The Blossoms to the toll point at the northern end of Manchester Road, was proposed. The crossing of the Mersey in the centre of the town was the greatest challenge; engineer Thomas Broadbent designed an eleven-arch road viaduct to keep the road at a higher level and minimise the gradients on the north and south of the town. The construction was not without problems and, on 26 August 1825, Wellington Bridge, which spans the Mersey, partially collapsed into the river, killing two workers.

When finally constructed, the new road was 24 yards wide, with the surface constructed of rolled angular stone and guttering. The total cost was £36,000 and it was the task of the tolls at each end to recover the financial outlay. The new road opened on 3 July 1826 and was named after the Napoleonic war hero, Wellington. It was estimated that the journey from Manchester to London was cut from nineteen hours to eighteen as a direct result of its construction.

Wellington Bridge crosses the Mersey, linking both of the steep approaches to the town centre.

Above: The old toll bar, which stood at the corner of Wellington Road North and Manchester Road, was demolished in a road traffic accident in the 1960s.

Right: The signage on the A6 confirms its status as a major north–south thoroughfare.

Stockport West

Reddish Vale

Reddish

River Tame

Stockport Canal Route

A6 North

Savoy Cinema

Vernon Park

Stockport Town Centre

Heaton Mersey

Didsbury Road Saltway

Heaton Mersey Valley

Edgeley

Edgeley Park
Stockport County

Cheadle

Bramhall Park

Cheadle Hulme

Bramhall

Happy Valley

N

Stockport East

Bredbury

River Goyt

Romiley

Roman Lakes

Site of Samuel
Oldknow's Mill

Regent
Cinema

Marple

Hazel
Grove

A6 South

Lyme Park

N

Hopes Carr

The area of Hopes Carr in Stockport is of significant importance to the town for two very contrasting reasons. The area is a square of land that is bordered by Middle Hillgate, Wellington Street, Waterloo Road and Spring Gardens. It's currently an area of overgrown woodland at the back edges of industrial units, but in the eighteenth and nineteenth centuries it was the centre of Stockport's silk manufacturing.

The industrial development of the area began in 1759 when Stockport's second silk mill was built in Hempshaw Brook Valley, to the west of a piece of agricultural land called the Glebe belonging to the local parish church. The Tin Brook (Hempshaw Brook) was dammed to create Higher Carr Dam, which impounded water to drive the waterwheels in the mills below.

The earliest known mills, built by Charles Davies, were at the junction of Spring Gardens and Lavenders Brow. The mills and the land were bought in the late 1790s by Thomas Hope, who built Middle Carr Mill and Upper Carr Mill to create a series of cotton factories that stretched along the narrow valley. The valley was named Hopes Carr after Thomas, and by the end of the nineteenth century had become an important industrial area of Stockport, containing cotton mills, a hat works, a large tannery and houses for the factory workers.

The Tin Brook flows into a man-made culvert that directs the water under the town and into the River Mersey.

Churchgate Mill and the cobbled rise of Lavenders Brow, up which mill workers would have climbed from the valley, still remain today, as does the chapel on the corner of Orchard Street, which dates from 1788 and was first accessed via a footpath from Waterloo Road.

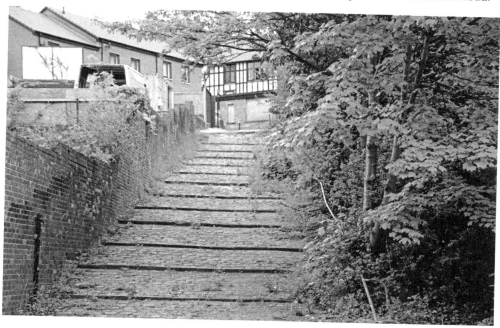

Above: Lavenders Brow rises up from the Carr Valley to its junction with Spring Gardens.

Below: The former chapel on Waterloo Road is a Grade II-listed building.

Hopes Carr and the Stockport Air Disaster.

Hopes Carr, however, does have a darker side in Stockport's history as the site of the Stockport air disaster of 4 June 1967, when a Canadair C-4 Argonaut owned by British Midland crashed, killing seventy-two passengers and crew of the total of eighty-four on

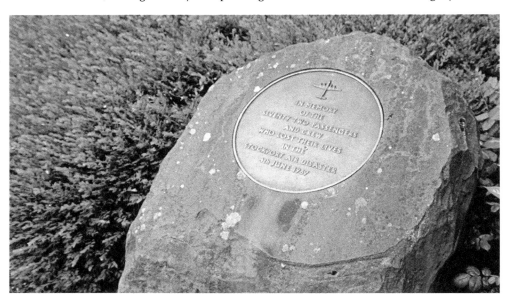

Above and below: Two memorials relating to the Stockport air disaster sit at the head of Hopes Car; one remembers the victims and the other praises the bravery of the rescuers.

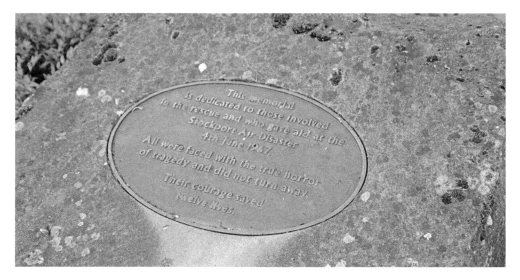

board. The aircraft, chartered by Arrowsmith Holidays, had left Palma, Majorca, at 5 a.m. for its return trip to Manchester Ringway. It seemed an uneventful Sunday morning. The weather was grey with drizzle and low cloud and the town was just waking up to a quiet Sunday. Close to Hopes Carr the members of the Salvation Army band were tuning up for a concert at a nearby old folks' home and the police were getting ready for their morning shift at the newly built headquarters on Lee Street.

There were few people around to witness the tragic developments but those who were there noted the plane's low approach from the direction of Woodbank Park. Their first concern was that it was going to hit the gasworks or the flats at Covent Garden but the plane banked low, narrowly missing a factory chimney and gaining a little altitude, before dropping from view behind St Mary's Church into the shallow ravine of Hopes Carr.

The aircraft dropped onto a long row of concrete garages, destroying cars and igniting a series of petrol fires but despite the impact most of the plane remained intact, and rescuers were met by the sight of a small number of passengers stumbling from the wreckage, including stewardess Julie Partleton. Desperate attempts to free the many passengers who survived the impact were made by the heroic men and women who were first on the scene. Sadly, as the fire in the fuselage took hold, they were beaten back by the intense heat, and many of those who survived the impact perished in the ensuing inferno.

The inquiry into the disaster concluded that, because of a fault in the fuel system, the engines were starved of fuel as it reached its last leg of the journey. The pilot, Captain Harry Marlow, survived and was cleared of all blame for the incident, with many people believing that his heroic struggle with the controls deviated the aircraft away from an area of high population.

Strawberry Studios is located on Waterloo Road, just 100 yards from the site of the disaster. It opened in the same year, 1967, under the name Inner City Studios.

Stockport Brinksway

The River Mersey leaves the viaduct, passing by low-rise offices and the glass and concrete symmetry of the town's bus station, squeezing between modern retaining walls and the sides of derelict mill buildings. It passes remnants of Stockport's industrial past, glides under an old bridge by The Woolpack public house and past the Stockport Pyramid, a six-storey structure clad in blue glass. The Pyramid was completed in 1992 and was designed to be the first of five pyramids to be erected along this stretch of the river, which would be named the Kings Valley.

The Co-operative Bank took control of the building when the developer went bust before the valley could be completed and the single building now operates as their telephone banking centre. The sole legacy of the idea seems to be that Junction 1 of the M60 is now known to one and all as the 'Pyramid Junction'. On the opposite bank to the Pyramid are steps down to the river. The Brinksway Caves can be seen through the foliage on the Cheadle side of the river, set in the high crops of red sandstone, which are a feature of this area of Stockport.

The old bridge with the Woolpack reflected in the Mersey's tranquil waters.

The Co-operative Bank.

The Trans Pennine Trail (TPT)

The TPT is a national coast to coast route for walking, cycling and, in some places, horse riding. It passes through vibrant cities, peaceful countryside, timeless villages, historic market towns, and romantic Pennine moorland. It links the North Sea at Hornsea to the Irish Sea at Southport – a distance of 215 miles (346 kilometres). The route was officially opened in September 2001 and has been developed and maintained by a unique partnership of twenty-seven local authorities. In Stockport, the Kings Reach Bridleway is approximately 1 mile long, flanking the River Mersey to the south and King Reach Business Park to the north. On the far bank of the River Mersey rise sandstone cliffs, with the man-made Brinksway Caves. The Mersey Valley provides a green corridor for wildlife and is home to herons, kingfishers and salmon, with various species of flora along the riverbank. The section of TPT through Stockport is mostly traffic-free and surprisingly level too, considering the terrain along the way. The multiple surfaced paths make these sections suitable for everyone. Stockport Metropolitan Borough Council is committed to promoting walking experiences for local people and improving the path and trail surfaces. The 'Walking for Health' programme includes: Walk Stockport, Walkaday, and the Green A to Z's guides, which give information on walking and cycling routes within Stockport.

The TPT is well signposted throughout the Stockport area and there is plenty of information along the route.

Stockport Caves

The air-raid shelters on Chestergate allowed families to shelter from the bombs dropped in the Second World War. They were opened in 1939 and were the largest purpose-built air-raid shelters for civilians in the country, providing shelter for as many as 6,500 people during the enemy attacks. The standard of accommodation was so good that local people often referred to them as the Chestergate Hotel.

However, the air-raid shelters form only a fraction of the tunnel system that wends its way underneath parts of the town centre. The tunnels have played an important part in the social and industrial development of the town and have had a number of uses since they were first excavated.

The main geological feature of the area around the town centre is red sandstone rock, which is soft enough to be excavated by hand and it was not uncommon for local people to build residences into the rock faces along Underbank and Chestergate. In fact, the air-raid tunnels were extended from small domestic dwellings carved out of the rock.

An extensive set of tunnels was constructed to feed the mills around Stockport with water power. The first ones were excavated to feed the town's two corn mills, which were

The red sandstone rock, next to the air-raid shelters, viewed from Merseyway car park.

owned by the lord of the manor – one close to Lancashire Bridge and the other on Millgate. Sir George Warren constructed more tunnels to supply water to his mill on Castle Yard where a 40-foot waterwheel provided power. Henry Marsland, who owned Park Mills, which were on the site now occupied by Sainsbury's, tapped into water sources in the nearby Goyt, which drove several more waterwheels.

The caves along the side of Brinksway, which are now bricked up, were built by navvies working on the construction of Stockport Viaduct. Many hundreds of them would turn up in the town but had nowhere to live so they used their digging tools to create a shanty town hewn out of the rock face.

There have been many rumours associated with the tunnels over the years. One of the most popular suggests that there is an extensive tunnel that runs from the Old Rectory at the top of Churchgate to either Marple Hall or Bramall Hall. There is, in fact, a fault line, which runs from the site of the old almshouses near the Rectory all the way to Marple Hall, and it is possible that it could have been widened for mining operations.

The old Stockport caves are clearly visible from the bridge over St Mary's Way in Portwood.

Heaton Mersey Valley Nature Park and Conservation Area

Heaton Mersey Vale Nature Park opened in 2006, the result of a riverside regeneration project to transform this derelict area, which was once a bleach works to the west and railway embankments to the east, into an urban nature spot. Today, the park's wildlife habitats include woodland, scrub, hedgerow, orchard, various types of grassland and ponds. All of this makes it a popular place for walkers, cyclists, runners, horse riders, canoeists, fishermen and bird watchers, although it is still not widely known about, even to those living close by.

The first discovery you will encounter as you enter the trail from Craig Road is Sidings Community Orchard, so named because it was once part of the area owned by Heaton Mersey Power Depot in the days when steam engines carrying goods created a significant amount of traffic on the line from Manchester Central. The orchard is a mix of established trees and newer stock planted after the park officially opened in 2006. Orchards may support over a thousand species of animals, insects, plants and fungi and provide important habitat for a number of bird species, such as bullfinch, robin, fieldfare, blackbird, and linnet, as well as the Pipistrelle bat and wood mouse. Butterflies can be sighted in the species-rich grasslands and in the woodland areas, where birds can feast on the hawthorn and blackthorn berries. Birds such as chiffchaffs, chaffinches, wrens, mistle thrush, redwings, blackcaps and whitethroats have been recorded here and throughout the park

The paths of the old railway lines are still preserved and provide useful pathways across the area. Heading west, past Vale Road Farm, you'll find the large curve of a weir

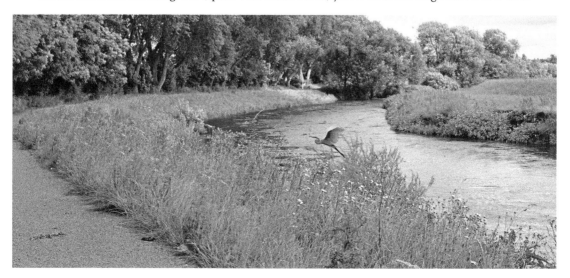

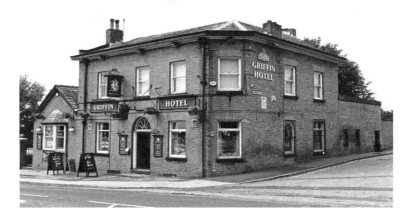

The Griffin Hotel is a short walk up the rise from the banks of the River Mersey.

The old millpond off Craig Road is a peaceful setting for local anglers.

The old weir at the head of the mill is a reminder of the area's industrial past.

directing the water flow down the river. This is the site of Samuel Oldknow's Bleach Works, which was built in 1785 transforming Heaton Mersey village from a quiet agricultural community into a centre of industrial processing and manufacture. Around 1785 he chose a piece of land by the river at the bottom of the track that is now known as Vale Road for his new venture – a bleach, dye and print works. The ready supply of water from the Mersey provided both power via a waterwheel and water for the washing and bleaching of cotton cloth that took place here. On the corner of Vale Road and Craig Road, a small flight of steps will take you up to one of the old millponds that are now used by local fishing enthusiasts.

A short stroll up Vale Road, the northern section of which is still laid with its original cobbles, will take you into the heart of the Heaton Mersey Conservation Area. There is lots to discover here, including the streets of Park Row and Vale Close, which contain the original dwellings for working people who flocked to the area for employment in the bleach works and brick-making industries. At the top of the cobbled rise is the Crown Inn, which dates from the 1700s, and Vale Close Cottages, which are some of the oldest buildings in the area, dating from the 1600s.

The geography of the area has not changed significantly over the years. The gradual rise from the river follows the same route that the workers from the bleach works would have trodden each evening after their long shifts. Between the linear path of Vale Road and the descending curve of Station Road lies Heaton Mersey Bowl, a huge dip in the ground, which was once used as a laying-out area for cloth from the bleach works that had to be

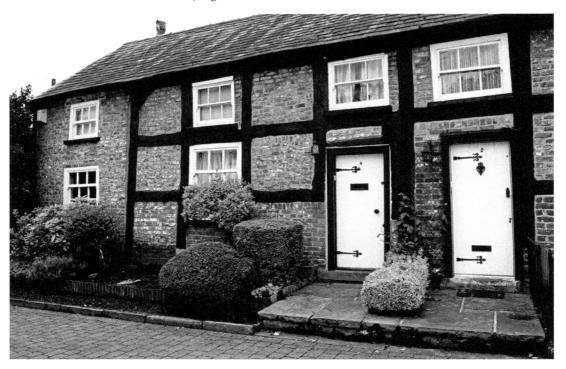

The former workers cottages are a feature of the area around the Crown Pub.

Isaac and Hannah Thorniley's graves lie in the spot once occupied by Grundy Hill House.

exposed to the elements for some months so that the elements could finish the process started with boiling the material in lime or caustic soda.

East from the site of the bleach works, on the corner of Didsbury Road and Harwood Road, the preserved graves of Isaac and Hannah Thorniley can be found. They were local landowners and their graves lie in what would have been the corner of their garden, which stood at the front of Grundy Hill House (or Foxglove House as it was locally known).

Across Harwood Road is the Griffin Hotel, which was built by the great-grandson of Isaac and Hannah in the early 1830s. Thomas Thorniley, the last in the line of family landlords, died in 1899 and in 1921 his widow sold the premises to Holts Brewery, who have managed the pub ever since. The unusual thing about the graves is that they are not in consecrated ground. Isaac and Hannah died in 1804 and 1792 respectively, and St John's Church, a few hundred yards to the west, was not constructed until the 1850s.

Cutting down towards the river, through the Green Pastures housing estate, will bring you to the western end of the Mersey Vale Nature Park on the banks of the River Mersey, where you will find the wildflower meadow on the edge of a small woodland area, where damsons (wild garlic), bluebells, red campion and honesty can be found.

The Crown Inn and the Salt Road through the Heatons

The Crown forms part of a group of buildings that were originally a tiny hamlet beside Parrs Fold and Vale Road, which, together with the hamlet of Grundy Hill just to the west, were the core of what later became Heaton Mersey village. It is possible that The Crown emerged to serve local drovers or stockmen who would rest their animals overnight at Parrs Fold as they drove their horses and carts along Didsbury Road, which formed part of the old saltway from Manchester to Northwich.

As road traffic grew during the second half of the eighteenth century, the position of The Crown was enhanced and the pub developed a reputation as a 'Tom and Jerry' shop. The word 'Tom', referring to a male animal, suggested that The Crown was almost exclusively the domain of men. The word 'Jerry' was local slang for a low public house or beer shop. Sometimes such premises were unlicensed but usually were allowed to sell beer, ale (without hops) and porter. The more disreputable houses sold 'Jerry beer', which was of poor quality, usually home-brewed and referred to as 'hooch'. In its early days, The Crown would have just sold beer as it did not obtain a licence to sell spirits until around 1833. There is evidence that around this time, in order to boost its profits, it also operated as a truck shop.

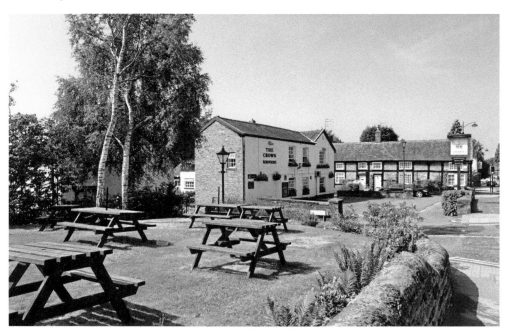

The Crown today.

A truck shop was an establishment that supplied provisions and other goods to working people in exchange for employee tickets or vouchers that they had received in part payment of wages. The practice was much abused by local employers and often resulted in workers falling heavily into debt. Samuel Stocks, who owned the nearby bleach works, was regularly fined for engaging in the practice by Stockport Police Court but boasted he had made substantial amounts of money by restricting his workers' spending power to shops in which he had a vested interest.

It may have been for his self-interest that Samuel opposed the granting of an extension of The Crown's license for spirits in September 1833. However, his colourful description of The Crown, delivered in court, gives an intriguing snapshot as to how the premises were viewed by some locals at the time. He insisted that the pub

> has no accommodation for travellers and the only use that I know the house may be is to be a nuisance to the neighbourhood and as a harbour for vagabonds of most classes and an enticement to my workpeople. It is impossible for me to describe the difference in the state of the population since the introduction of these pests of places – drunkenness, gambling, fighting and every abomination has increased to an extent beyond belief and our only resource is to request the Magistrates not to extend the evil.

Nevertheless, The Crown was granted its license and, in addition to serving beer and spirits, made use of its ovens to open a commercial bakery. It is likely that the practice was started around 1814 by Samuel Dutton, who produced bread and other popular items such as seed cake and hot cross buns. The use of the ovens was extended to support the community; on certain days local people could take their own bread to be baked on the premises for a charge of a half penny per loaf.

The side of the Crown Inn used to have a 'loaf hole' through which bread was dispensed to local residents.

The Coming of the Railways and the Lost Stations of Stockport

The influence of the Victorians on all aspects of British society was immense. Their era was a period of rapid change that left its mark on the development of life across the nation, transforming the landscape of Britain.

The coming of the railways was one of the things that impacted most on the development of Stockport since it opened up areas to wealthy families who wanted to live in peaceful semi-rural environments, away from the pollution of the busy industries of Manchester and the town centre and allowed the movement of goods in and out of the town, improving its commercial status.

During the nineteenth century, railway companies built lines that criss-crossed the borough. The London and North Western Railway connected Stockport with Manchester and Crewe to the south, and Liverpool and Buxton to the west and east. The line built by the Midland Railway followed the route of the modern Metrolink line, which terminates at East Didsbury, but extended south through Cheadle Heath, through Bramhall and on to New Mills. The most romantic of the lines, however, was built by the Cheshire Lines Committee with picturesque stations, a feature of the route, which meandered from Liverpool, through Northenden and Cheadle to Tiviot Dale in the town centre and out to Godley in the east. Stations to serve the borough opened rapidly.

Heaton Norris
Heaton Norris, on Wellington Road North, was the first station on the LNWR route out of Manchester. It opened in 1840 under the name of Stockport Station but, with the building of the viaduct, and the opening of Stockport Station in 1843 it was renamed Heaton Norris and handled passenger services until its closure on 2 March 1959. The great warehouses that stood next to the station still stand imposingly on the main road but the station itself has disappeared beneath a car park for local small businesses.

Cheadle Heath
Cheadle Heath Station was opened by the Midland Railway. It was one stop south from Heaton Mersey and linked with New Mills South through the 2-mile-long Disley Tunnel. The link allowed the Midland Railway to offer a London to Manchester journey of only 3 hours 35 minutes. The station closed to passengers on 2 January 1967, and to goods on 1 July 1968. Although a single line still operates, nothing remains of the station and the goods yard, and slow-line platforms have been developed as a supermarket.

Cheadle Station
Cheadle Station was located on the Glazebrook East Junction to Godley line of the Cheshire Lines Committee Railway (CLC). It opened on 1 December 1865 and was, in fact, a mile

73

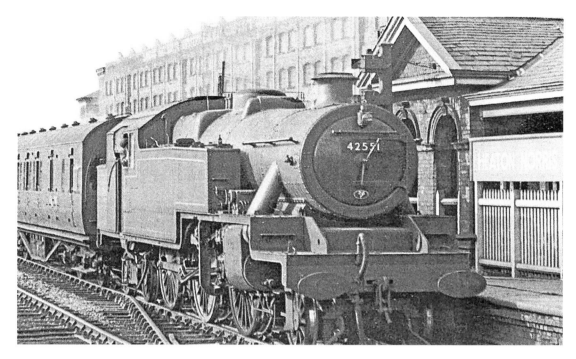

Heaton Norris Station was situated behind the enormous goods warehouse on the A6, Wellington Road North.

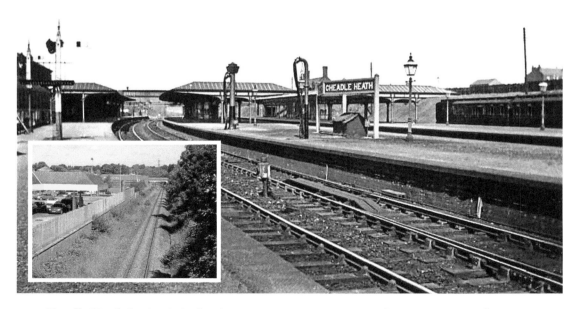

Cheadle Heath Station in its heyday. *Inset*: Morrisons supermarket now occupies the site on which Cheadle Heath Station once stood.

Cheadle Station at the turn of the nineteenth century, looking towards Stockport. The picture is taken from where the car park to Golden Days Garden Centre now stands.

north of Cheadle village. The station was built in typical CLC style, with gabled roofs and a stationmaster's house incorporated into the building. The station was closed on 11 September 1964 but has survived as the Cheshire Lines Tavern, with the nearby railway workers' houses in private ownership.

Heaton Mersey

Heaton Mersey Station opened on 1 January 1880 as part of the Manchester South District Railway that connected Manchester Central to Stockport Tiviot Dale. It was served by trains that called at all stations between Manchester Central and Manchester London Road via Stockport Tiviot Dale. Fourteen trains ran in each direction and although Heaton Mersey was one of the quieter stations on the line, it was still very busy. On Sunday 4 May 1969, the very last train services operated out of Manchester Central. The odd freight train continued to pass through the station site during the summer of 1969, but on 17 August the line was disconnected at Chorlton Junction. The deep cutting in which the station was located was filled in and a housing estate constructed on the site.

Tiviot Dale

Tiviot Dale opened on 1 December 1865 as a branch of the Stockport Timperley and Altrincham Railway. It gave the town its first east–west through line, providing a link with the Stockport and Woodley Junction Railway, which had its terminus at Portwood. Today, the M60 motorway cuts through most of the site formally occupied by the station, although the overgrown platforms can still be accessed via a footpath to the north of Lancashire Hill Bridge.

Above: A busy Heaton Mersey Station circa 1905.

Right: The line from Tiviot Dale to Portwood Station ran parallel with where the hard shoulder of the M60 runs today. The grey bridge on the left of the picture replaced the old stone bridge carrying the line. Portwood Station stood roughly where the blue roundabout can be seen in the middle of the picture. The remains of the platforms for Tiviot Dale can still be seen behind the foliage on the left. The picture is taken looking north from Lancashire Hill Bridge.

Portwood

Stockport Portwood opened as a terminus station at the western end of the Stockport & Woodley Junction Railway's (S&WJR) Woodley to Stockport line on 12 January 1863. The line connected into the Manchester, Sheffield & Lincolnshire Railway's (MSLR) Hyde Junction line, which in turn gave access to Manchester via the MSLR main line between Manchester and Sheffield. When it opened, Stockport Portwood had a single platform located on the south side of the line. The platform was connected to Marsland Street by a sloping path. At street level, there was a booking office. A small building, which probably provided waiting facilities, was located on the platform. Tiviot Dale Station was only around half a mile away from Portwood and it was probably for this reason that Portwood closed on 1 September 1875. Today, the site of the station lies under the slip road to the M60 at the Portwood roundabout.

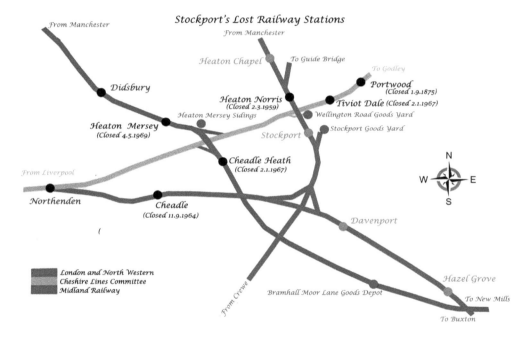

Canal Cruises from Heaton Norris

The Industrial Revolution in Britain started from around 1760, and wealthy merchants and mill owners were looking for a cheap way to transport their goods safely and in large quantities. The Manchester to Ashton Canal was opened in 1796 and, just a year later, Stockport was linked into the canal system by a new spur that ran from between Locks 10 and 11 at Clayton down into Heaton Norris at the top of Lancashire Hill.

The main purpose of the canal was the transportation of coal from the collieries around Ashton into Stockport. In addition, it was used to carry general cargo, such as raw cotton, to the local mills then return with manufactured goods. It also carried supplies of grain to William Nelstrop & Co.'s Albion Mill in Heaton Norris. The canal was just over 4 miles long and was unusual in that it didn't contain a single lock. It passed through Openshaw, Gorton, Debdale Park and Reddish before arriving at a wharf and warehouse complex at the top of Lancashire Hill. Today, the biggest reminders of its existence are the presence of The Navigation pub, just outside Albion Mill and Wharf Street, which still runs behind the back of the premises.

There was, however, an unexpected benefit for Heatons' residents with the rise of a passenger boat service, which sat side by side with the busy trade route. In May 1799

The name of the Navigation pub, at the top of Lancashire Hill, gives a clue to the site of the canal terminus.

The old entrance to the Stockport Canal can still be found on the Ashton Canal, in Openshaw, just to the east of the Etihad Stadium.

the Manchester Mercury gave notice that a passenger boat service would open between Heaton Norris and Piccadilly. The success of the service was immediate, with the appeal to passengers being the relatively short journey time and the comfort of the boats compared to a rickety ride down cobbled streets into the city centre.

The initial operations saw boats leaving Heaton Norris for Manchester from 8 a.m. with the last boat returning from Piccadilly Wharf at 6 p.m. The service ran daily and its success was such that the service was expanded, with operators offering a 2-hour trip from Stockport to Stalybridge via the Ashton Canal and the newly opened Huddersfield Narrow Canal.

The fare from Heaton Norris into Manchester was 1s for a front seat and 8d for a seat at the back (around £4 and £2.75 in today's money). To travel into Stalybridge was slightly more expensive at 1s 3d for a seat in the front cabin and 9d for a seat at the back of the boat, with passengers coming back the same day paying only half fare for the return leg of the journey. Such was the novelty of the new mode of transport that groups of people hired canal boats for the day and cruised between Heaton Norris, Manchester, and Ashton at their leisure.

Sadly, the canal began to decline as a result of competition from the railways and roads and was starting to fall into dereliction as early as 1922, with commercial traffic ceasing in the 1930s. The canal was dredged in the 1950s but this did not result in a resurrection of trade and it was finally abandoned in 1962. The line of the canal can still be followed having being turned into a surfaced pathway along most of its length.

The Regent Marple

Thomas Carver and his family, who were strict Congregationalists, arrived in Marple in 1859. One of his first projects was to build the Union Rooms on Stockport Road which, in line with his strict teetotal beliefs, included a coffee tavern to tempt working men away from the temptation of alcohol. There was also a reading room and a mission room in which services were held. Carver died in 1920 but the rooms continued to survive for another twenty years, until dwindling attendances finally put paid to its original use.

In June 1929 an application was submitted by Walter Stott to turn the building into a cinema and music venue, but for financial reasons the plans never came to fruition. However, in 1932 Ernest G. Allen purchased the rooms and secured planning permission to convert the property into a 545-seat cinema. After much interior renovation, the cinema opened at 6.45 p.m. on Monday 22 August 1931 with the inaugural film being *Sunshine Susie* starring Renate Muller, Hack Hulbert, and Owen Nares. A seat in the circle cost 1s or 1s 3d, and the cheaper seats in the stalls 7d and 9d.

Like many local cinemas, the Regent suffered from the advent of television and falling audiences resulted in the closing of the cinema on 3 August 1968. An application was submitted to the council to convert the premises into as bingo hall, but this was refused on the grounds that it would be 'injurious to the amenities of the area'. The council tried to acquire the premises themselves with a view to turning the building into a civic centre, but this plan was abandoned when James Lillis made an application for a renewal of a cinema licence and the Regent was saved. The cinema was completely refurbished and reopened in May 1969. Under the management of the Lillis family, the cinema has gone from strength to strength and continues to provide a quality cinema experience for local residents.

The Regent.

Marple

The Industrial Revolution brought work and prosperity into the village of Marple during the 1790s; before this most of the villagers worked mainly on the land or as outwork weavers. Samuel Oldknow (1756–1828), an industrialist at this time, financed and set up mills in and around the area. He was also involved with the financing and construction of the Peak Forest Canal, which opened up a vital link to Manchester and other towns and industries. The workmen on the canals were called 'navigators', or 'navvies' for short, so along the route of the Peak Forest Canal there are a number of public houses with the name 'navigation' in their title. One such pub is The Navigation (at Lock No. 13) here in Marple. It is a Robinsons public house and dates back to the 1790s. Samuel Oldknow also developed roads, especially around his kilns and warehouse (shown in the photo), to help transport the goods quickly and efficiently. A railway, an essential link to Stockport and Manchester, was opened during the mid-1800s, allowing both goods and commuters to travel to and from the village. Marple was expanding at this time, so the increasing population required housing and shops. The once small village soon became a thriving town, and continues to be so over 200 years later.

The Navigation is a Robinsons public house, which dates back to the 1790s. The nearby bridge over the Peak Forest Canal is called Possett Bridge. A possett was a milk drink curdled with ale or beer and often flavoured with spices. It was served to the 'navvies' working on the canal.

The Savoy

Stockport is lucky to have two surviving independent cinemas: The Savoy in Heaton Moor and The Regent in Marple.

The Savoy was established fifty-seven years before my first visit. It was opened by the mayor of Stockport in March 1923. It had a balcony and seated over a thousand people. Audiences flocked to see its first screening – a silent production of *The Virgin Queen*, starring Diana Manners with accompanying music from Constance Cross's Ladies Orchestra.

This new entertainment gave the people of the Heatons a view into worlds previously unknown to them and they would certainly have revelled in the action and drama surrounding the life of Elizabeth I. Diana Manners, or later Diana Cooper, Viscountess of Norwich, was a young socialite who after working as a nurse during the First World War turned to an acting career. She achieved national success and built a fan base at home to rival that of later American film stars such as Betty Grable, Jean Harlow, and Katharine Hepburn. In her prime she had a widespread reputation as the most beautiful young woman in England, and appeared in countless profiles, photographs and articles in

The Savoy is a popular venue for Heatons' residents and those travelling from further afield.

newspapers and magazines. She died aged ninety-three in 1986, having starred in silent movies, 'talkies' and some of the first colour films.

The Savoy was a state-of-the-art cinema and was even able to boast the use of Prizma Color – a system pioneered by William Van Doren Kelley and Charles Raleigh that consisted of the use of different filters to add colour to various scenes in a black-and-white film. It was adapted for sound in 1930 and enjoyed huge success throughout the golden age of cinema. However, in 1938 it was badly damaged by fire and had to be closed for some months. With the coming of the Second World War, it provided much-needed light entertainment and screened regular newsreels from the conflict in Europe. It was also occasionally used as an evacuation centre for local families whose homes were under the most threat of bomb damage.

The cinema managed to survive after the war, despite the coming of television and the associated drop in cinema audiences. In 1971 it underwent a complete facelift, with its balcony being removed and the front boxed-in to provide a covered foyer and waiting area. The Savoy has been completely refurbished to a high standard with comfortable, luxurious and spacious seating. The cinema offers a varied programme that is constantly changing, offering something for everyone.

The photograph shows the spacious seating arrangement in the refurbished autitorium.

The Poco A Poco, Heaton Norris, 1939–87

It's hard to imagine while sitting in the peaceful surroundings of the Hind's Head pub, just off Manchester Road, that you are relaxing on a site steeped in the popular cultural history of the Heatons. The pub opened in 1987, replacing the legendary Poco A Poco nightclub and finally bringing to an end decades of variety entertainment that featured some of the biggest stars of the time, and a host of other local bands who sadly never rose to national fame.

The club had a rich and chequered history. It opened as the Empress Cinema on 6 May 1939 and had a seating capacity of 1,400. It was the last cinema to be built in Stockport for many years, given the forthcoming Second World War and the years of austerity that followed. The opening film was *The Scarlet Pimpernel* starring Leslie Howard, Merle Oberon and Raymond Massey. However, over the next two decades, financial difficulties resulted in it merging with The Savoy in Heaton Moor and its days as a cinema ended in 1959. Nevertheless, the ballroom remained open as The Empress Cabaret Club with another part of the building featuring The Flamingo Coffee Jive Club.

The Hinds Head stands on the site once occupied by the Poco A Poco.

During the early '60s its main attraction was as a bingo club but, after been badly damaged by a fire in 1967, it reopened a year later as the Poco A Poco nightclub and casino. As its reputation across the North West grew, it hosted a series of events featuring some of the biggest names in show business. On 7 May 1969, Frankie Howard recorded a TV show there and acts like Bill Hayley and the Comets, Billy Fury and Karl Denver (who is buried in Stockport Cemetery) often did week-long residences, drawing in the crowds who flocked from the towns and cities across the region.

Possibly its greatest claim to fame, however, came on 27 April 1970 when David Bowie took to the stage, just a few days before receiving his Ivor Novello award at The Talk Of The Town in London for 'Space Oddity', which had been voted as the best original song of 1969. The concert was organised through Stockport Schools' Sixth Form Union by pupils from Stockport Grammar School. David Bowie was second on the bill to Barclay James Harvest and it is rumoured that he slept at Stockport railway station after the gig having missed the last train back to London.

For a short time in 1980, as its use as a theatre and concert venue waned, the club took to presenting boxing matches as a means of continuing to be financially viable but, by 1982, the club had lost its iconic title and was under fresh ownership with its new name as 'Chesters'.

Its days ended in May 1987, when it was once again damaged badly by fire and, later that year, it was demolished and the site acquired by Whitbread to build the Hind's Head. Today, the only reminder of its existence is in the name of the road on which the Hind's Head sits. Empress Drive stands as a reminder of those distant days when crowds would flock along Manchester Road ready for an evening's entertainment at one of Stockport's most legendary venues.

The Empress Cinema is remembered in the name of the road outside the Hind's Head pub.

Stockport Garrick Theatre

The Stockport Garrick Theatre is situated on the corner of Exchange Street and Wellington Road South and is one of Stockport's gems. When the Dramatic Society of the Stockport Unitarian Church disbanded in 1901, local engineer Edwin Heys and some fellow members resolved to keep on the acting tradition of the town by forming a new society, which they hoped would attract capable amateur actors and present plays to the highest possible standards. Based on this dream, an inaugural meeting in the Church Coffee Tavern on St Petersgate resulted in Stockport Garrick Theatre officially coming into existence on 24 October 1901.

It was resolved to name the theatre after David Garrick, one of the greatest actors of the day; the theatre has risen to its ambitious aims, producing a wide range of drama and musical performances for over a hundred years. Indeed, as early as 1905 it was even experimenting with opera, undertaking an ambitious performance of *The Sorcerer* – a two-act comic tale by Gilbert and Sullivan. Challenging works by Ibsen and George Bernard

The Garrick Theatre has stood in its present location since 1920.

A postcard showing the cast of *A Winter's Tale*, posted in March 1906 with the message about the performance from one of the actors on the reverse.

Shaw featured in its season programmes and, at a time when performances by such playwrights were considered risky, the Garrick was never afraid to push the boundaries.

The theatre kept its doors and its curtains open throughout both world wars and attracted the admiration and support of numerous luminaries in the world of professional theatre, including theatre manager Annie Horniman, actor-manager Charles Charrington and his wife, actress Janet Achurch. On 10 May 2008, Sir Ian McKellen visited the theatre to unveil a plaque commemorating the theatre's foundation and its status as England's oldest small theatre. The plaque can be seen a short distance from the theatre on St Petersgate at the site of the coffee house where the original society was founded. A second plaque, on the same site, commemorates Sir Ian's visit.

Since those early days, the commitment and enthusiasm of the actors and volunteers have continued to sustain the Garrick. This enduring enthusiasm and success can be noted from the message on the back of a postcard sent on 26 March 1906. The writer, one of the cast members from *The Winter's Tale*, tells her friend:

This is just a flashlight of our show ... Winter's Tale has been a great success. The theatre Manager says if we could give it for a whole week at the theatre we should have packed houses every night...Ever so sorry it is over. Have quite enjoyed it. Much love from A.E.S.

Bramall Hall

Bramall Hall is a black-and-white timber-framed Tudor manor house with the oldest parts dating back to the fourteenth century. The house lies in 70 acres of landscaped parkland with lakes, woodland and gardens, all of which have a range of wildlife habitats. It is a Grade I-listed building that has stone foundations with an oak-timbered main structure joined together using mortise and tenon joints, with wattle and daub filling the spaces between the timbers. The name Bramhall is derived from the Old English nouns *brōm* and *halh*, meaning a secret place or nook where broom grows. Land in the area was given to Hamon de Massey *c.* 1070, although the manor of Bramhall dates from the Anglo-Saxon period. He was given the land by William the Conqueror following the Harrying of the North, which took place during the winter of 1069/70 to subjugate northern England. A rebellion led by Edgar the Æthling, who had a blood claim to the throne, took place across the north. William cruelly defeated the rebellion by ordering the villages be destroyed and the people killed, and, as a result, herds of animals and crops were burned. The people who survived the initial onslaught starved to death during the harsh winter months. Dating back to Anglo-Saxon England, the manor of Bramhall was described in the Doomsday Book in 1086 and was held by the Massey's. It was then owned by the Davenports, who built the present house, which dates to the late fourteenth century. The original building consisted of an open hall with two cross wings. The hall was floored over during the sixteenth century and the exterior walls were embellished with the intricate pattern of quatrefoils in squares.

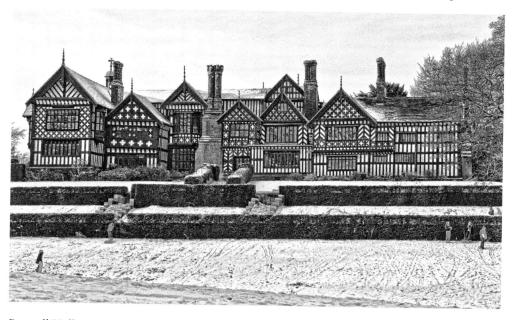

Bramall Hall.

Above left: There are a number of tall chimney stacks, with clustered moulded brick shafts, on the house. The Tudor period saw the brickmakers and bricklayers emerge as separate craftsmen who were able to rival the masons. They not only made standard bricks but also produced them in extravagant and elaborate shapes epitomised by those that formed the spiral twisted chimney stacks for which the period is renowned.

Above right: The octagonal bell-cote sits on the roof above the chapel to provide shelter for the bell. The early sixteenth-century chapel was restored in 1938. It has heavily moulded timber columns with curved braces and beams.

The Davenport's can trace their ancestry to John de Davenport, the second son of Thomas Davenport of Wheltrough, whose father was a knight during the late fourteenth century. The legacy of the Davenports of Bramall Hall is all around Stockport and within the county of Cheshire. They remained there for 500 years before selling the estate in 1877 to the Manchester Freeholders Company. Davenport Park lies on land originally owned by the Davenport's. The estate then passed through a number of owners: the Nevill family, John Henry Davis, Hazel Grove and Bramhall Urban District Council, before passing on to Stockport Metropolitan Borough Council. During 2016, the house and surrounding buildings have again been restored and refurbished, following a £1.6-million restoration programme by the Heritage Lottery Fund. Improvements have been made to the historic rooms, architecture, and fabric of the building. The stable block has been converted into a visitor centre, which houses a gift shop and classroom facilities. The new glass fronted café opens onto the walled garden for outside dining.

Bramhall Park

Ladybrook flows through the park and is flanked by several ponds. Some of the woodland in the south of the park is designated as a Grade B Site of Biological Importance (SBI). This is the name given to the most important non-statutory sites for nature conservation in Greater Manchester and Cheshire and provides a means of protecting sites that are of local interest and importance. The woodland leads directly into Carr Wood Local Nature Reserve and Bramhall Park provides vital links with nearby green spaces such as Happy Valley and Newhouse Farm woodland. These woodlands are quite diverse, ranging from wet woodland to mixed broadleaf and coniferous woodland.

The ponds attract a variety of wildfowl including geese, herons, coots, ducks and the elegant mandarin duck and the woodlands too have a large number of British bird visitors. The artificial ponds were once stocked with trout when they were first built, but the ponds are no longer fished.

The estate once covered over 2,000 acres in extent and, like many of the large park areas of the day, was used for hunting and the grazing of cattle. The artificial ponds, the extensive planting of trees, the altering of the course of the Ladybrook and the drive up to the house were all changes made when the grounds were remodelled during the 1880s. Bramall Hall gives you a glimpse into the past. The rooms are beautiful and Tudor in style. They contain spectacular plaster ceilings, wall paintings and fine examples of architecture, furniture and paintings from different periods. The Victorian kitchens and the servants' quarters show what the living conditions were like for both the gentry and the servants. The hall and park are both open to the public and feature woodland, gardens, a visitors centre, café and a children's play area.

The elegant mandarin duck is a regular visitor to Bramhall Park.

Happy Valley

Happy Valley, which is located near Bramhall Park, is a 17-hectare designated nature reserve, home to a wide variety of habitats and wildlife, and a Site of Biological Importance (SBI). Sites of Biological Importance are locally designated sites that represent some of the best habitats and collection of species in Greater Manchester. This local nature reserve was designated a place of value to nature in 1999 because it provided good opportunities for the local community to enjoy the local wildlife. It is part of the Lady Brook Interest Trail because parts of the woodland are considered ancient woodland, and they contain species that reflect this. The Ladybrook, which flows through the site, provides a different range of wildlife habitats in a largely urban environment and is a tributary of the River Mersey, with the confluence at Cheadle. Happy Valley offers a variety of freshwater habitats, such as brown trout and rich bank-side flora including butterbur, sweet cicely, and pendulous sedge. The ponds provide an excellent habitat for amphibians such as frogs and smooth newts, and has a variety of plant species. Friends of Happy Valley play a vital role in the management of the reserve.

The earliest use for the term 'Happy Valley' is found in Samuel Johnson's *The History of Rasselas, Prince of Abissinia*, so, since the mid-eighteenth century it has been described

The entrance to Happy Valley, on Bridge Lane, Bramhall, is easily found.

The stepping stones across Ladybrook in Happy Valley.

as a place of remarkable beauty, tranquillity, and contentedness. Happy Valley here in Stockport is just that. The brook that runs through Ladybrook Valley has a number of name changes along its route, namely Norbury Brook, Ladybrook, Mickerbrook and, further away from Stockport towards the Peak District, Bollinghurst Brook. The source of the brook begins in the Peak District and ends at the confluence with the River Mersey at Cheadle and has a total length of 15 kilometres and a gradual fall of 275 metres. Near Hazel Grove, Stockport, the river is used to define the boundary between Cheshire and Greater Manchester. It passes through a variety of changing landscapes and habitats especially in Happy Valley and Bramhall Park. A number of existing rights of way have been linked up to offer walkers a footpath route along the full length of the valley.

Reddish Vale Country Park

Reddish Vale Country Park offers a pleasant escape from the busy suburban environment that surrounds it; its long history supports tales of farming, milling, textile manufacturing and quarrying. When you walk in its pleasant, green surroundings, you enter a world that has been shaped over centuries, containing reminders of the part it has played in the lives of ordinary people. Sadly, some of the buildings, such as River View Cottages, are no longer there. Condemned as unfit for habitation in 1961, their last inhabitants were two sisters: Mrs Emma Adshead and Mrs Nelly Ridgway, both in their eighties, who were reluctant to move from the peace and tranquillity of River View. They lived there all of their lives; their father had been employed at the Calico Print Works, which once stood in the vale. Similarly, the nine houses that stood under the railway viaduct were pulled down in 1914, despite offering a service to local walkers who were sold refreshments by their enterprising inhabitants. Dominating the landscape today is the imposing sixteen-arched brick viaduct, built in 1875 by the Sheffield and Midland Railways Committee in order to complete their Romiley to Ashbury line over the Tame Valley. The viaduct drastically changed the outlook of the valley and it is said that a local witch, who was unhappy with it being built, put a curse on anyone who dared count the arches.

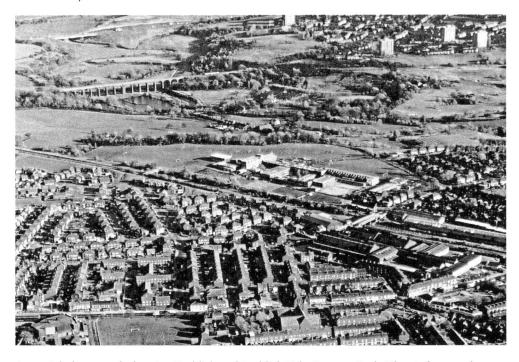

An aerial photograph showing Reddish and Reddish Vale Country Park. The viaduct can be seen in the top left corner of the photo.

The park covers almost 400 acres and is comprised of millponds, wetlands, woodland, flat riverside meadows and a butterfly conservation park and not forgetting the River Tame. The area is an excellent place for walking, cycling and horse riding with path links to the Goyt and Etherow, Saddleworth and Longdendale trails, into Stockport town centre, Denton in Tameside and Woodley. The park also includes a section of the Trans Pennine Trail, which is a coast to coast route from Hornsea in the east to Southport in the west. Nestling on the banks of the River Tame is Reddish Vale Golf Club. Over a hundred years ago Frank William Reed was hitting golf balls on a piece of land known as Wilcock Eye. So taken was he with the surroundings he purchased an imposing manor house, South Cliffe, leased 100 acres of land and commissioned Dr Alistair McKenzie to inspect the area and design the course. McKenzie went on to become one of the era's foremost golf course designers, constructing courses across the world including the Augusta National, home of the US Open. Today the course must rank as one of the most picturesque in the country as its fairways twist and turn around the Tame; in many quarters it is considered to be one of the top 100 courses in the world.

Reddish Vale Country Park has been developing for over forty years on land that was originally the site of a print works and according to *Grace's Guide to British Industrial History 1891* it is listed as a calico printers owned by Bradshaw, Hammond & Co. They had acquired the works in 1862 from Becker Bros., who had operated a print works on the site from 1840. However, a water-powered print works is known to have been working there before 1800. The River Tame became heavily polluted during this time because of the many mills and works using its water. A natural habitat for wildlife was therefore virtually

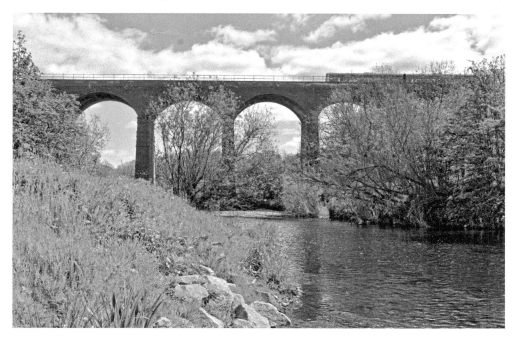

The River Tame flows through the park on its way to meet the River Goyt in Stockport town centre to form the River Mersey. The imposing sixteen-arched brick viaduct was built in 1875.

The photograph shows the top millpond, which forms a natural habitat for wildlife. The viaduct can be seen in the background.

non-existent in the area. So, when the print works closed in 1975 and the buildings were demolished, the land eventually became an area of conservation. A variety of wildfowl visit the millponds and wetlands, including geese, herons, grebes, cormorants and coots, with sand martins and kingfishers nesting in the banks of the river. The visitors centre offers information about the walks within the park, the wildfowl to be seen and the butterfly meadow. The centre and the café are operated by volunteers from the Friends of Reddish Vale. Further information can be found within the park, including signpost directions for the various walks and signs about the wildlife. The Butterfly Conservation Park has been quoted as being a 'haven for wildlife' because it contains plants and flowers that attract butterflies, moths, caterpillars, birds and small mammals. The posts around the park give information that encourages children (and adults) to read and learn about the visiting butterflies.

The River Tame

The source of the River Tame lies close to the Pennine Way in West Yorkshire. However, the 'named' river starts from Readycon Dean Reservoir on the moor above Denshaw, historically a part of the West Riding of Yorkshire but now a civil parish of the Metropolitan Borough of Oldham in Greater Manchester. The high moorland is sparsely inhabited, but there are fabulous views on a clear day. The upper Tame and its tributaries are comparatively shallow headwater streams, but water levels in the Saddleworth area rise very quickly after rain. Some of the headwaters are impounded for public water supply and some volumes of water are also taken from the river by the Huddersfield Narrow Canal. The river flows south through the historic, beautiful and photogenic Saddleworth villages of Delph, Dobcross, Diggle, Uppermill and Greenfield. The industrial history of the area can be seen in the architecture of the buildings, which are constructed from locally quarried millstone grit. This material is difficult to carve, so many of the buildings are plain yet functional. The traditional small-scale home weavers' businesses became threatened during the late eighteenth century as the larger, purpose-built mills emerged, which were powered by the Tame and its tributaries. New village communities built up around these mills during the early nineteenth century. Diggle's new mill had the biggest waterwheel in England at that time, and the large Alexandra Mill in Uppermill, which can still be seen, was steam powered. There was also a paper mill at Greenfield and dye works at Delph, so the river, much like the Goyt, was a polluted waterway during the nineteenth century due to the dyes, bleaches and other effluents put into the river by the many mills. However, the anti-pollution efforts of the last thirty years of the twentieth century have resulted in many fauna distributions along the river being re-established. The Tame then flows through Reddish Vale Country Park, which lies in the Tame Valley, north of Stockport town centre. It is a place of recreation for the large populations of Brinnington and Reddish, offering a place of tranquillity and interest that is easily accessible.

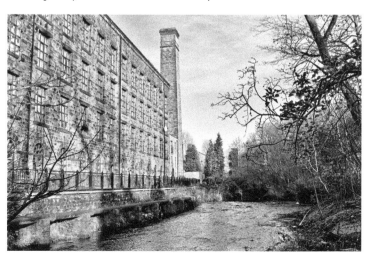

Alexandra Mill stands alongside the River Tame, in the village of Uppermill.

Acknowledgements

We would like to give special thanks to a number of people and organisations who have helped us to compile the information for this book:

Mr Dennis Robinson (Director) and Daniella Martin (Communication Manager), Robinsons Brewery. You can book your brewery tour online at *www.robinsonsvisitorscentre.com* or call 0161 612 4100 for further information.
Ted Doan (General Manager) and Ben Wainwright (Deputy Technical Manager and Photographer), Stockport Plaza Trust Limited. You can contact the Plaza at *www.stockportplaza.co.uk* or call 0161 477 7779 for further information.
Stockport Heritage Trust Centre, St Mary's Church, St Petersgate. You can contact them at *www.stockportheritagetrust.co.uk* for further information.
Heaton Mersey Village Conservation Group. You can contact them at *www.hmvcg.co.uk*
Phillip Catling at the War Memorial Art Gallery.
Rita Keenan for supplying the old postcards of Stockport.
Ben Wainwright for the original photographs of the Plaza.
Mike Frisbee for the original photograph of the Savoy.
Molly Page for the original photographs of the Roman Lakes.
Anna Dowson for the original photographs of Vale Road Cottages and the Griffin Hotel.
Mary Griffiths James for the photograph of Grundy Hill House.
Barbara Brookes and W. Rhodes Marriott AIBP, ARPS for the photograph of Merseyway and the fire station from 1953.

We would also like to acknowledge the following publications, which were an invaluable source of information when researching some of the facts to go with the photographs:
Dranfied, Karen, *Wellington Road* (Stockport Heritage Book Series).
Hayes, Cliff, *Britain in Old Photographs, Stockport* (Sutton Publishing Ltd: 1997).
Morrin, Steve, *The Day the Sky Fell Down, the Story of the Stockport Air Disaster'* (Lithaprint: 1998).
Stockport Town Trail (Stockport Museums and Art Gallery Service: 1986).
Trumble, Jill, *St Mary's Graveyard Trail Guide* (Stockport Heritage Trust Series).
 We would like to thank all those listed above for permission granted to use copyright material in this book. Every effort has been made to trace copyright holders and to obtain permission for the use of copyright material.